Introduction:

This book is many years in the making. As an artist, making new drawings one after the other is very difficult. It is even more difficult to make each one more impressive than the previous one. With this book though, I aim to share my drawings with the world in hopes it brings joy to others. I hope that people enjoy coloring and have fun doing so. These drawings are for people to color and escape to their own creative world. This is only my first book, and many will come after it. These drawings themselves took a while to make along with having to choose which drawings to use. I hope all of you enjoy these creations I have made.

- Christopher Arredondo/ Arredondoart

The Beginning
Chapter 1:
Mandalas

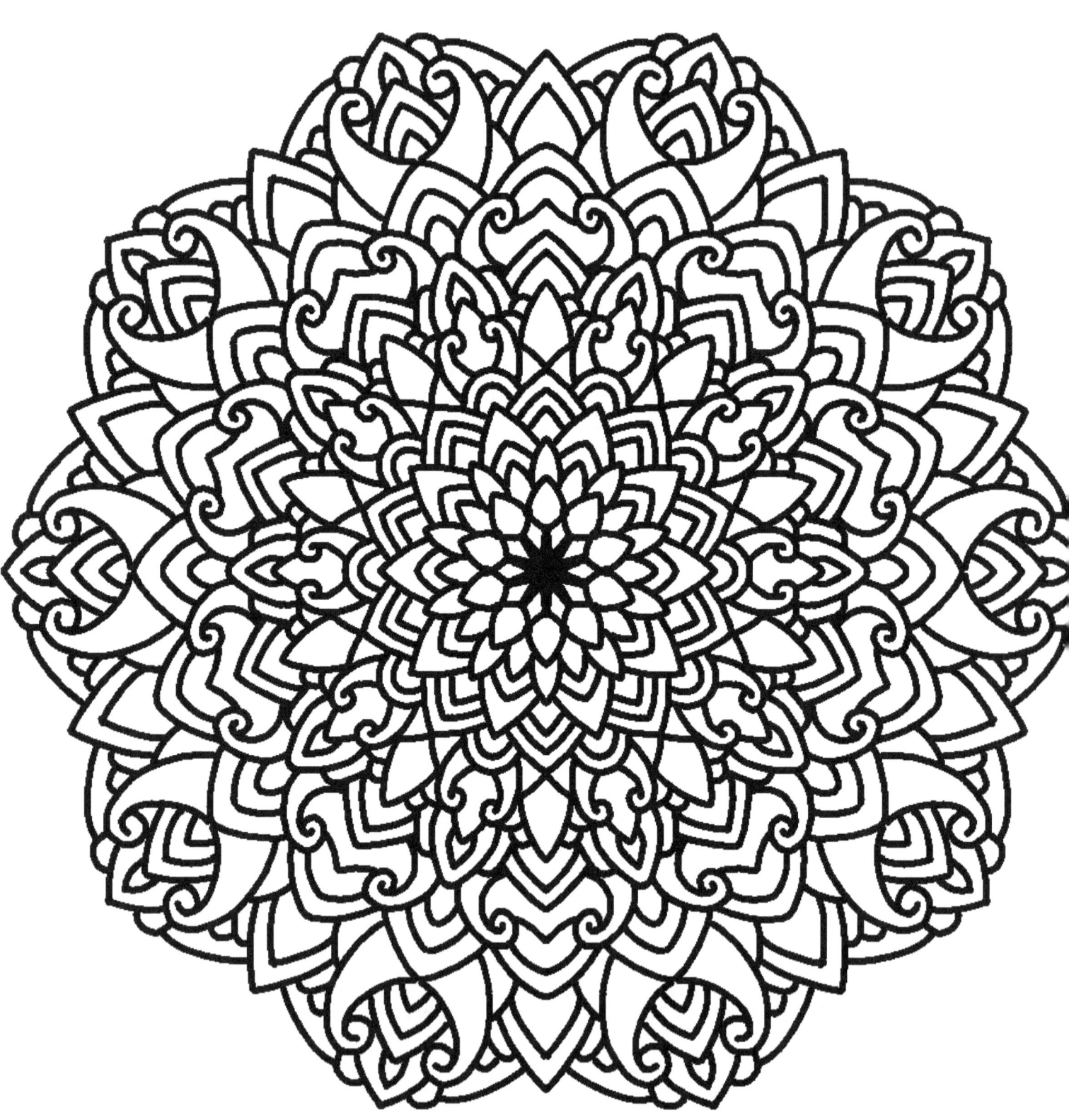

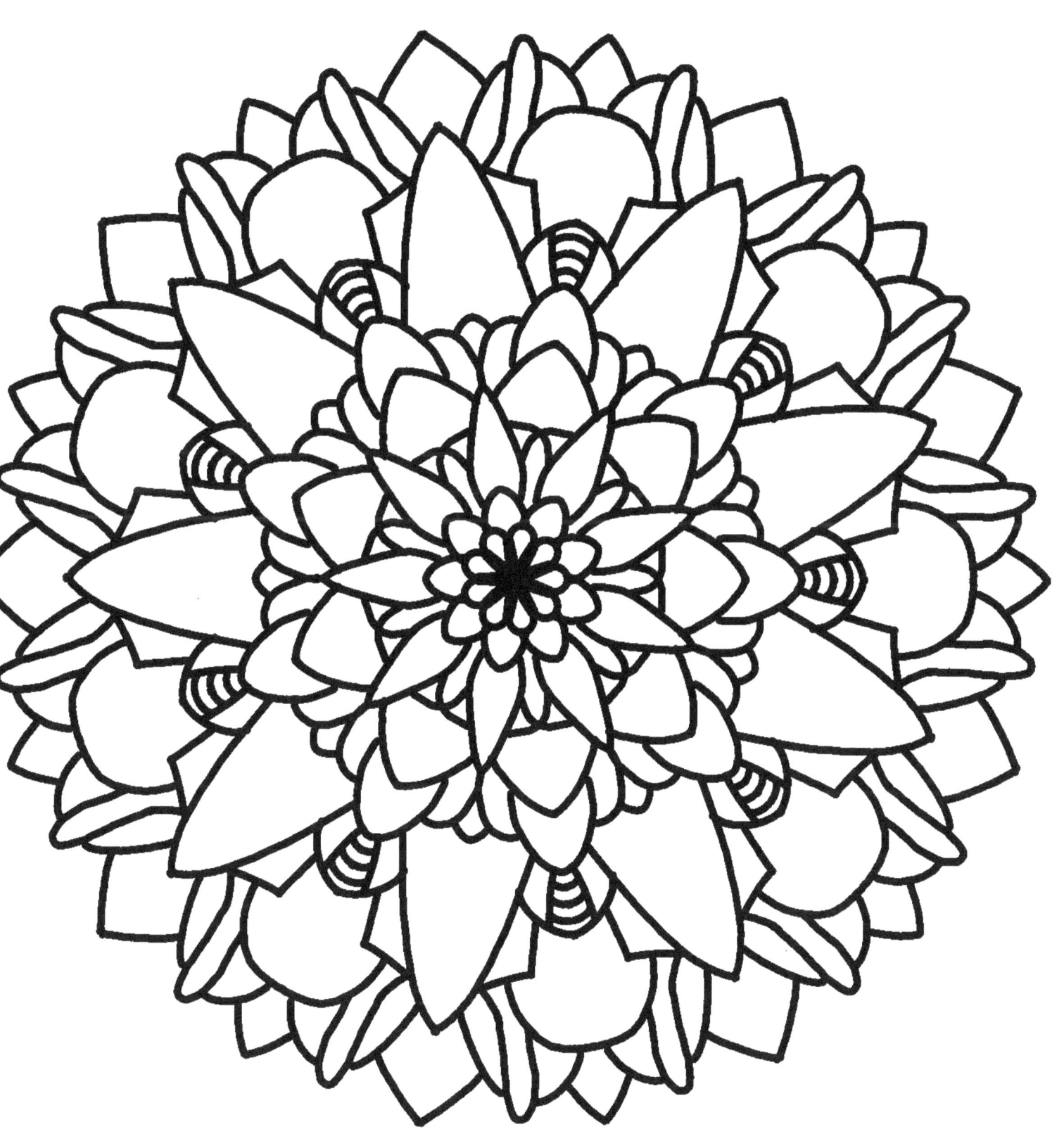

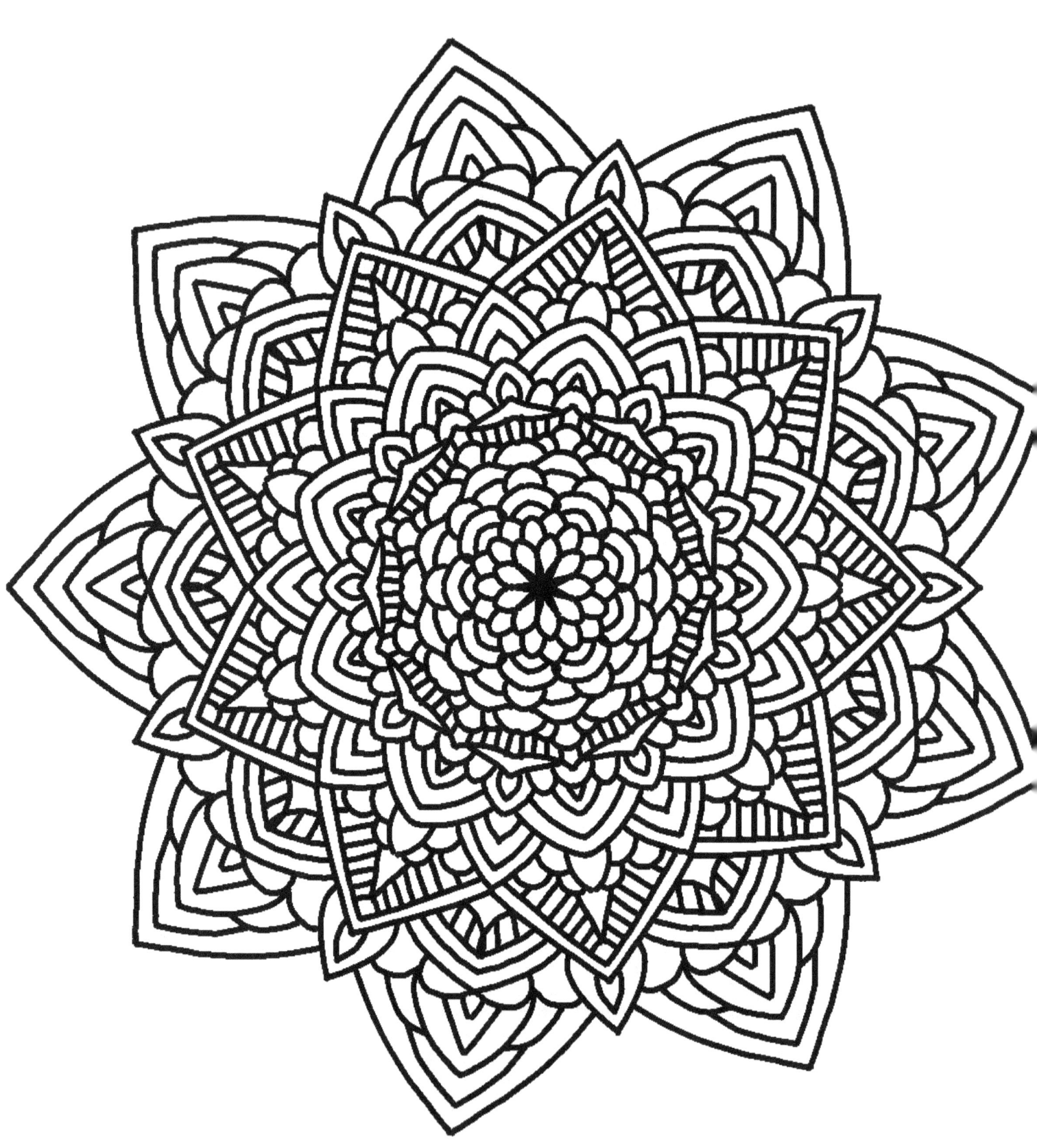

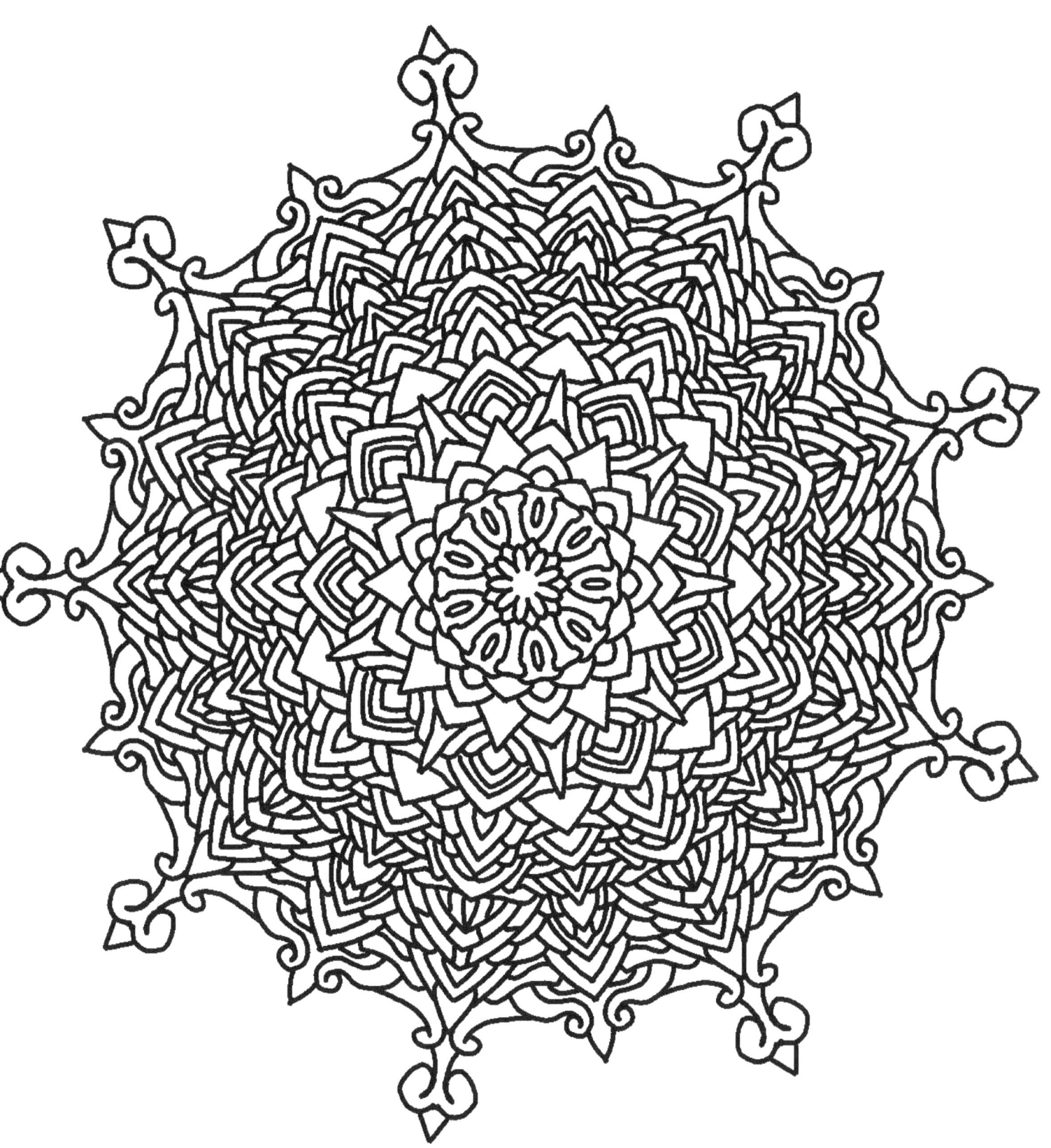

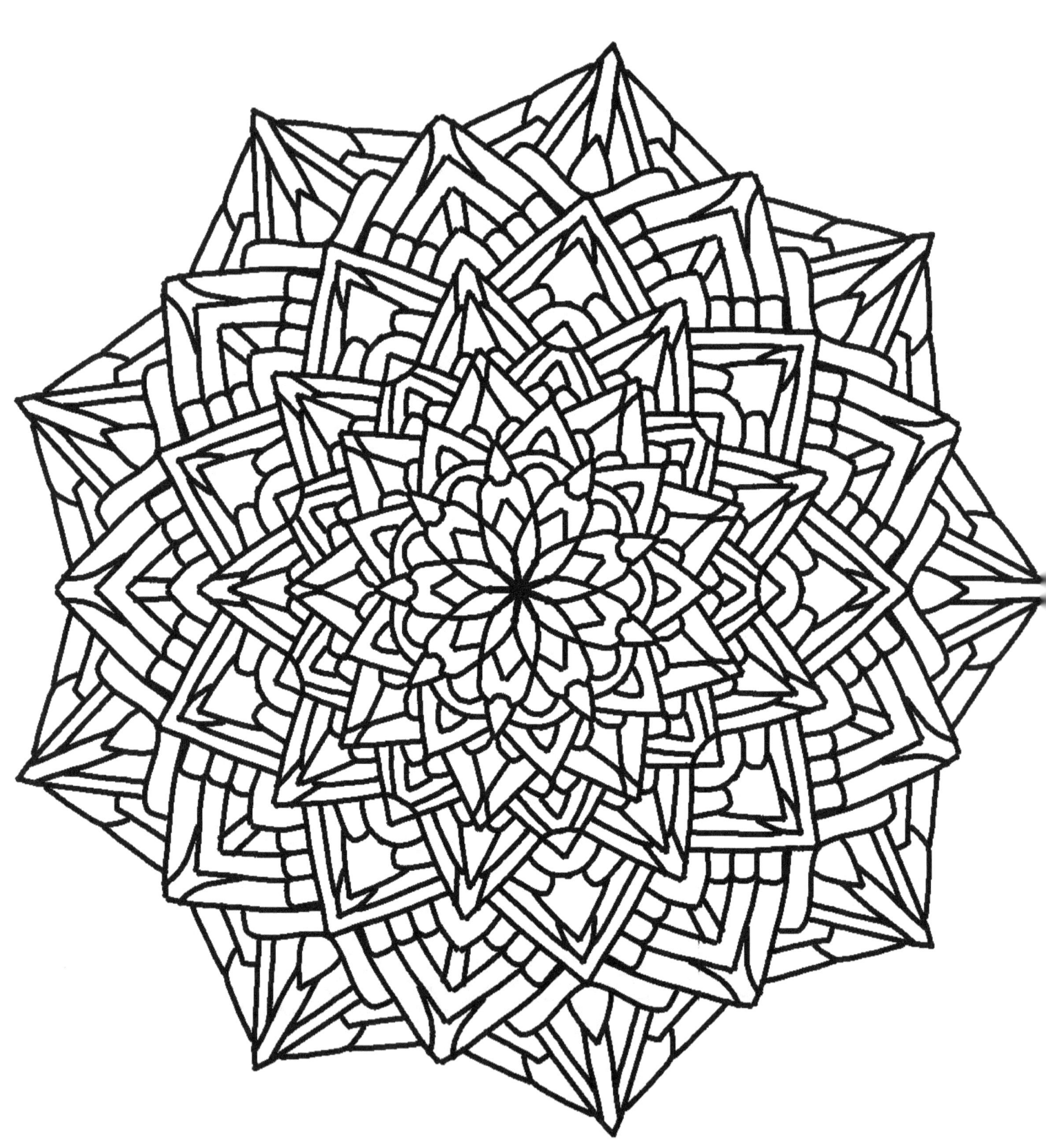

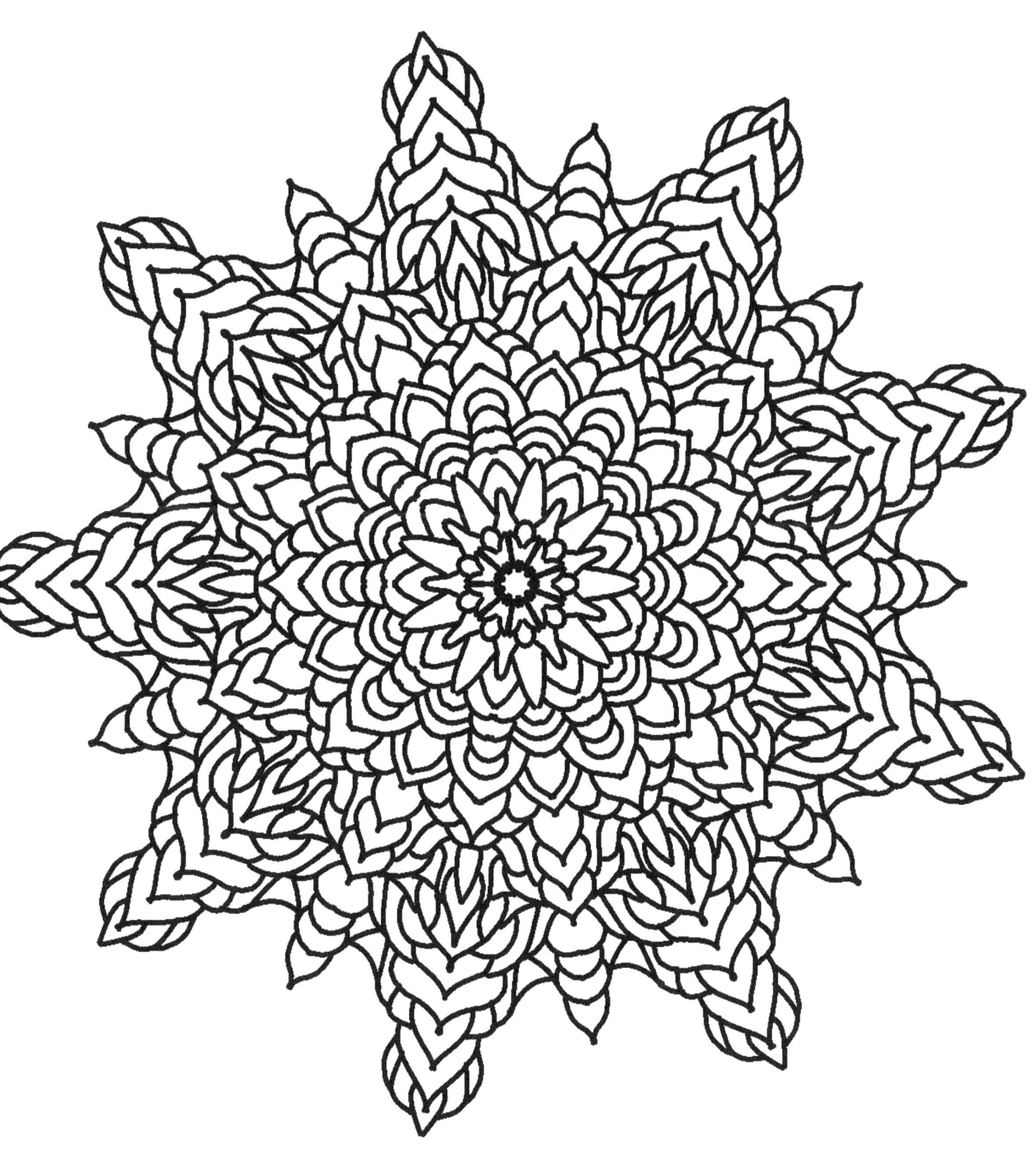

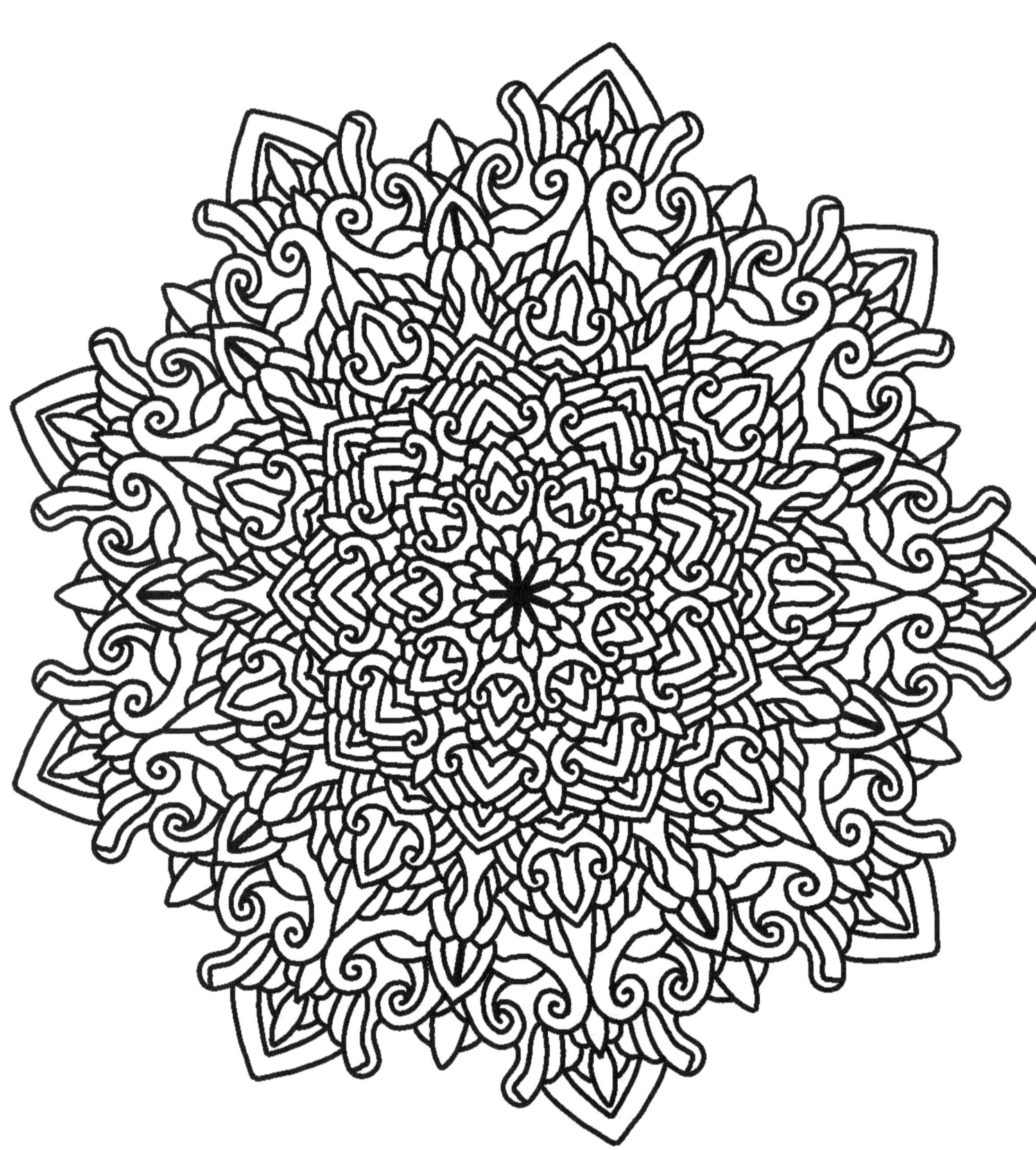

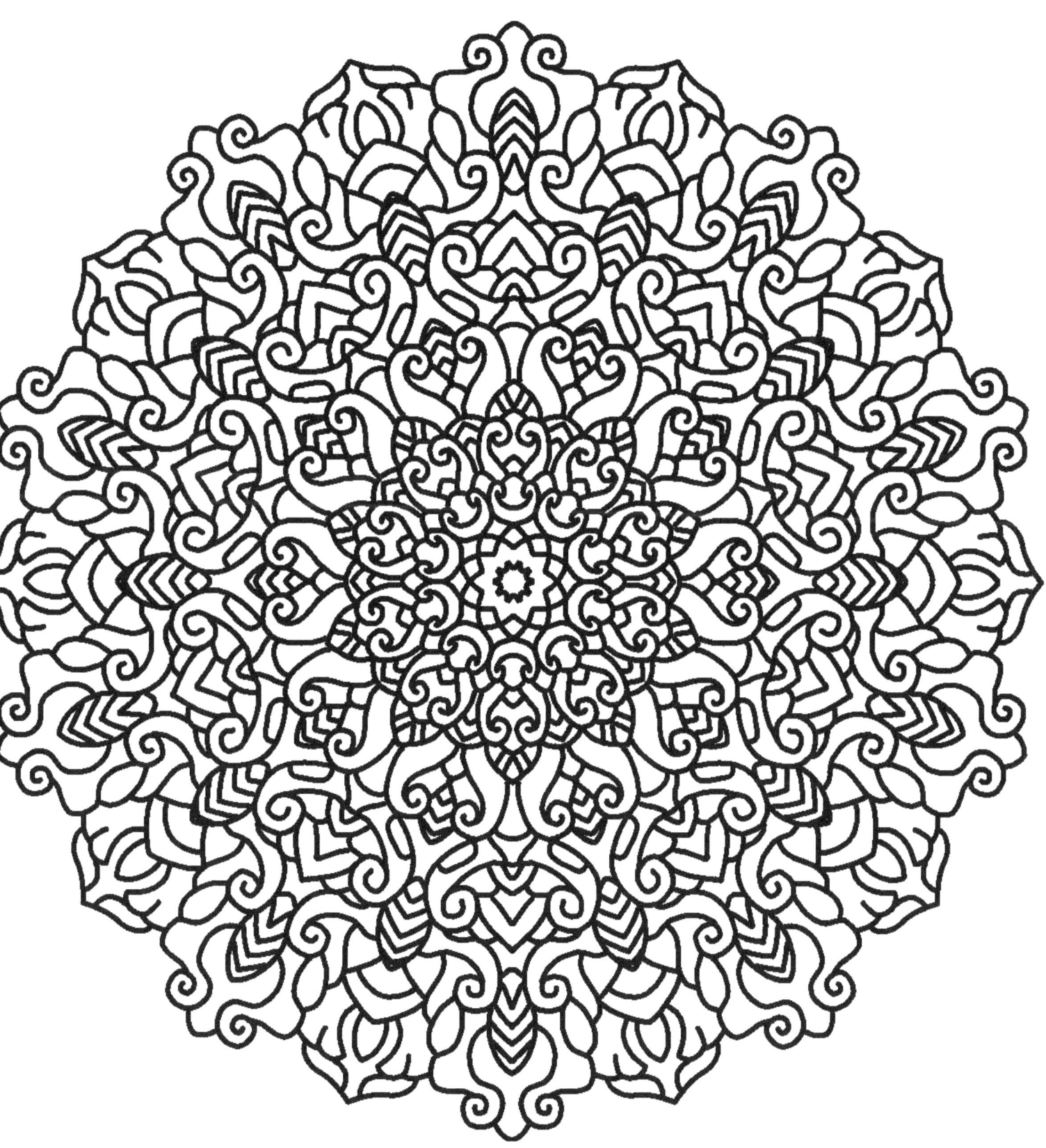

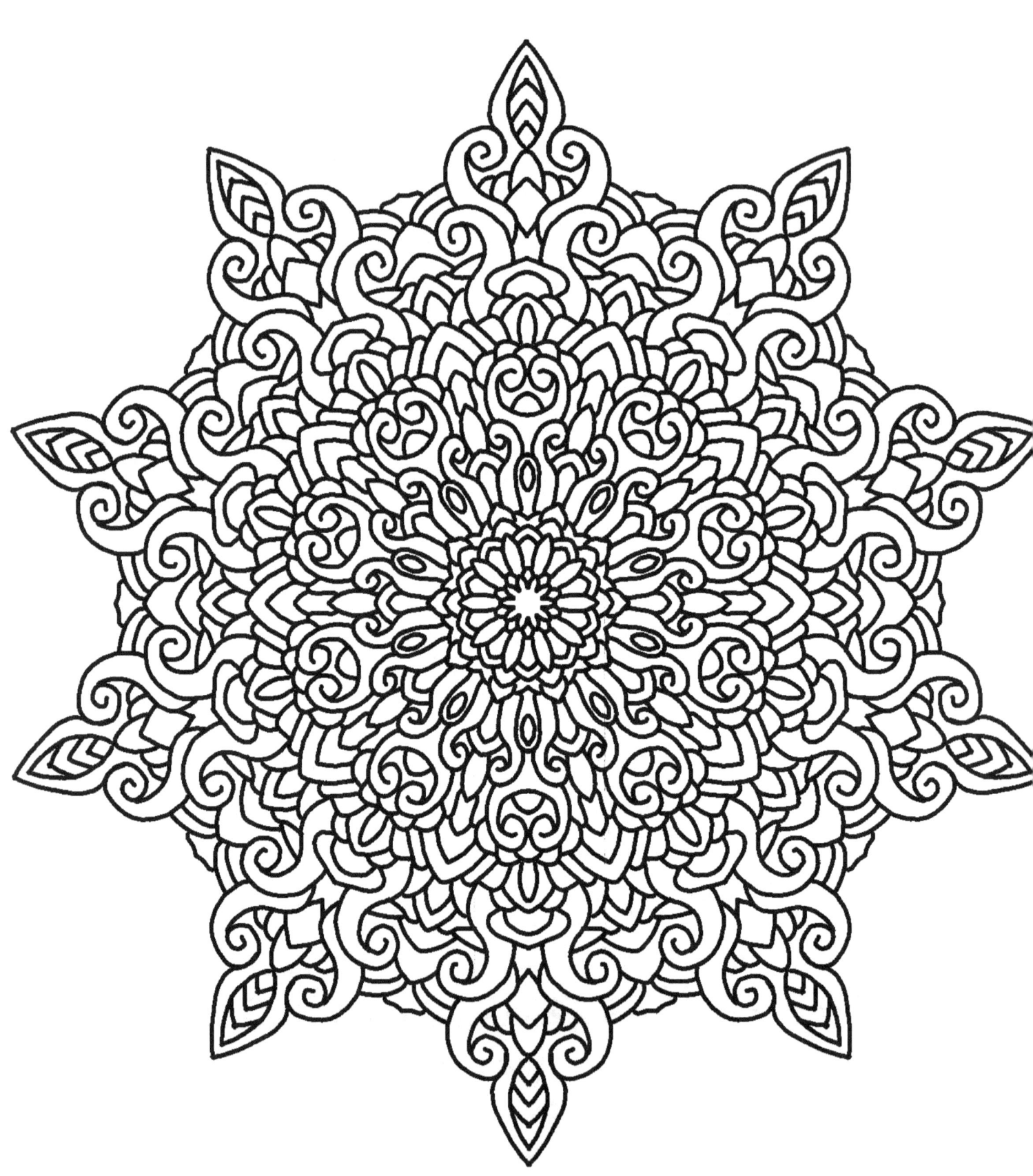

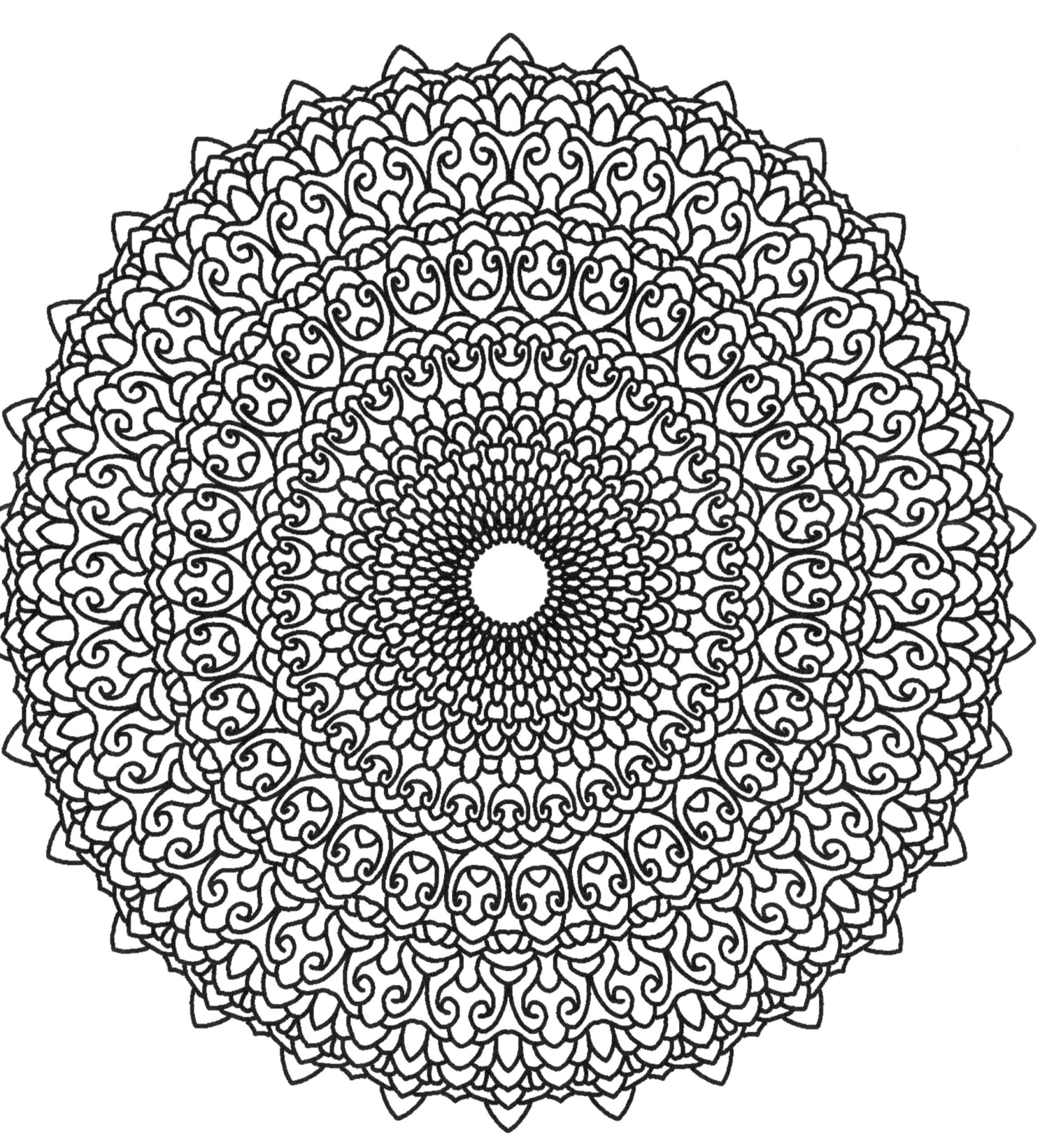

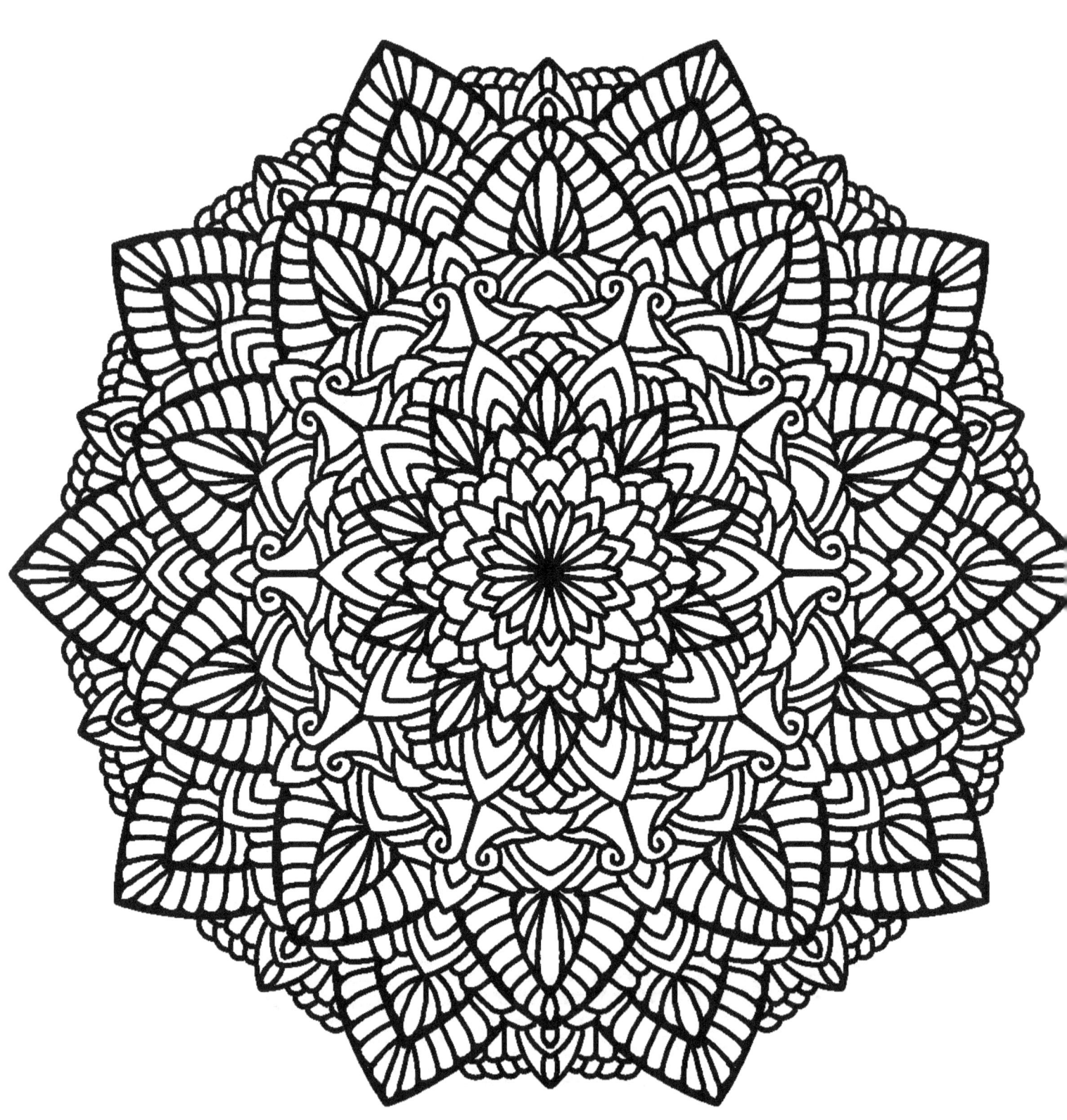

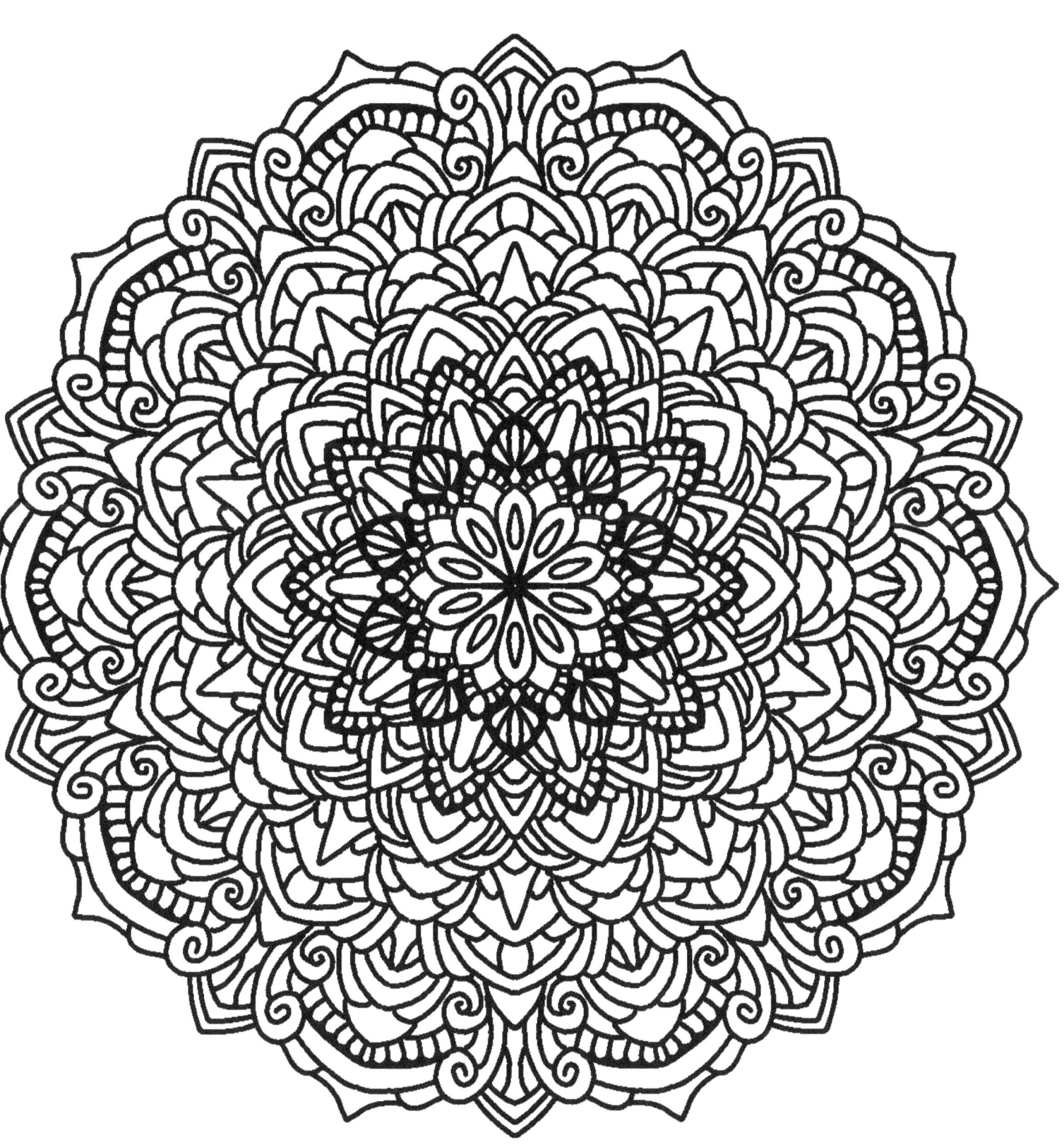

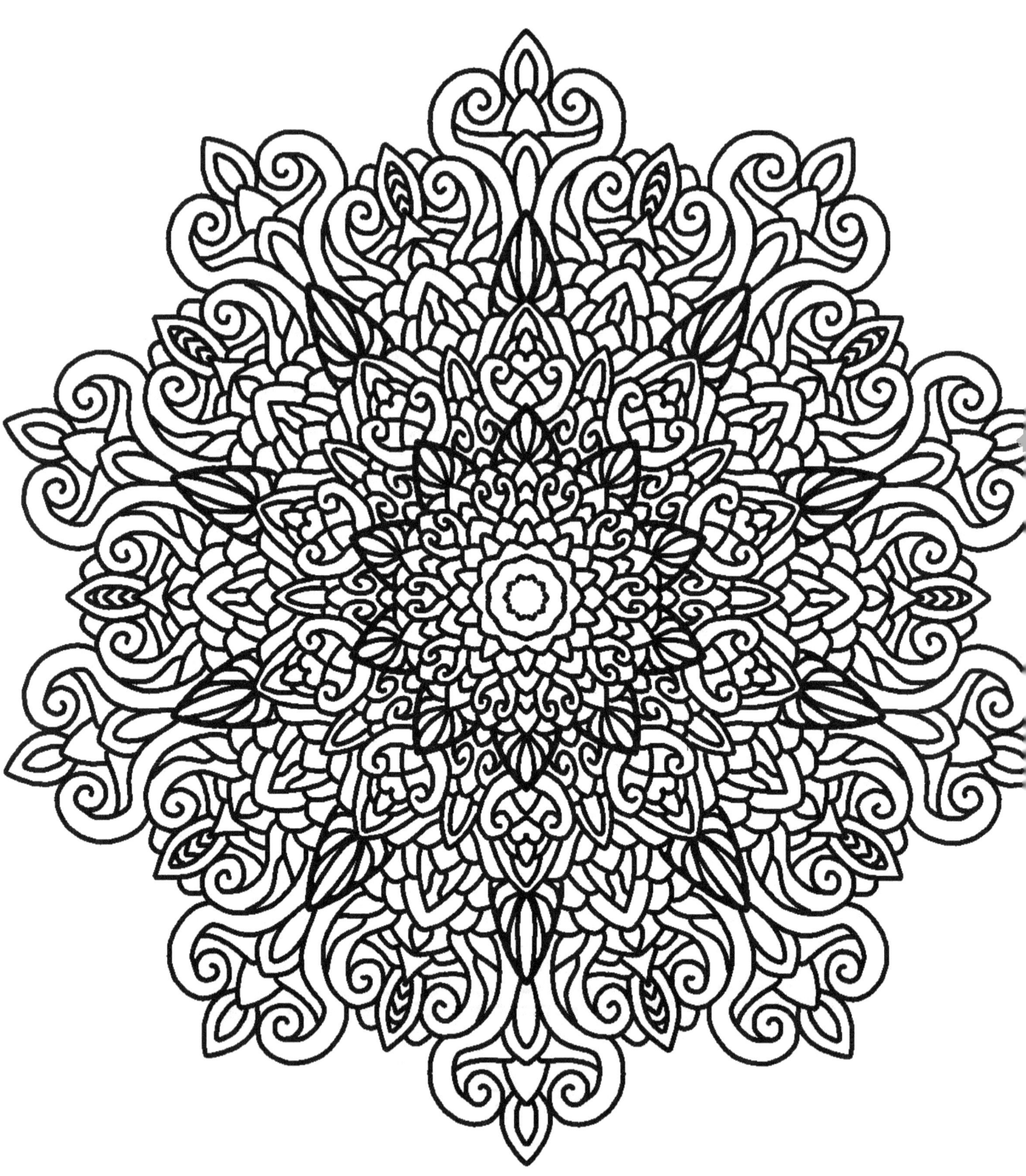

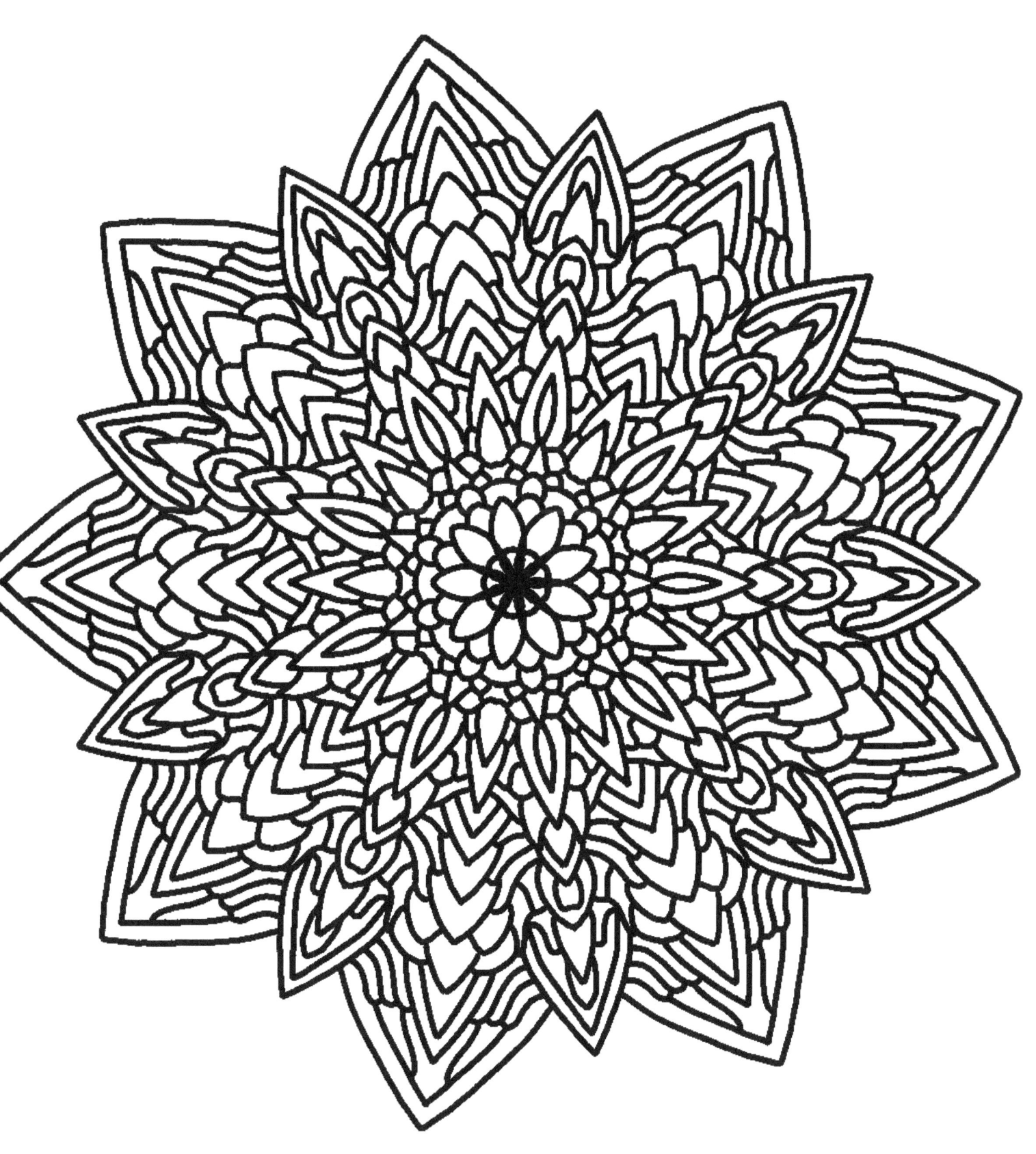

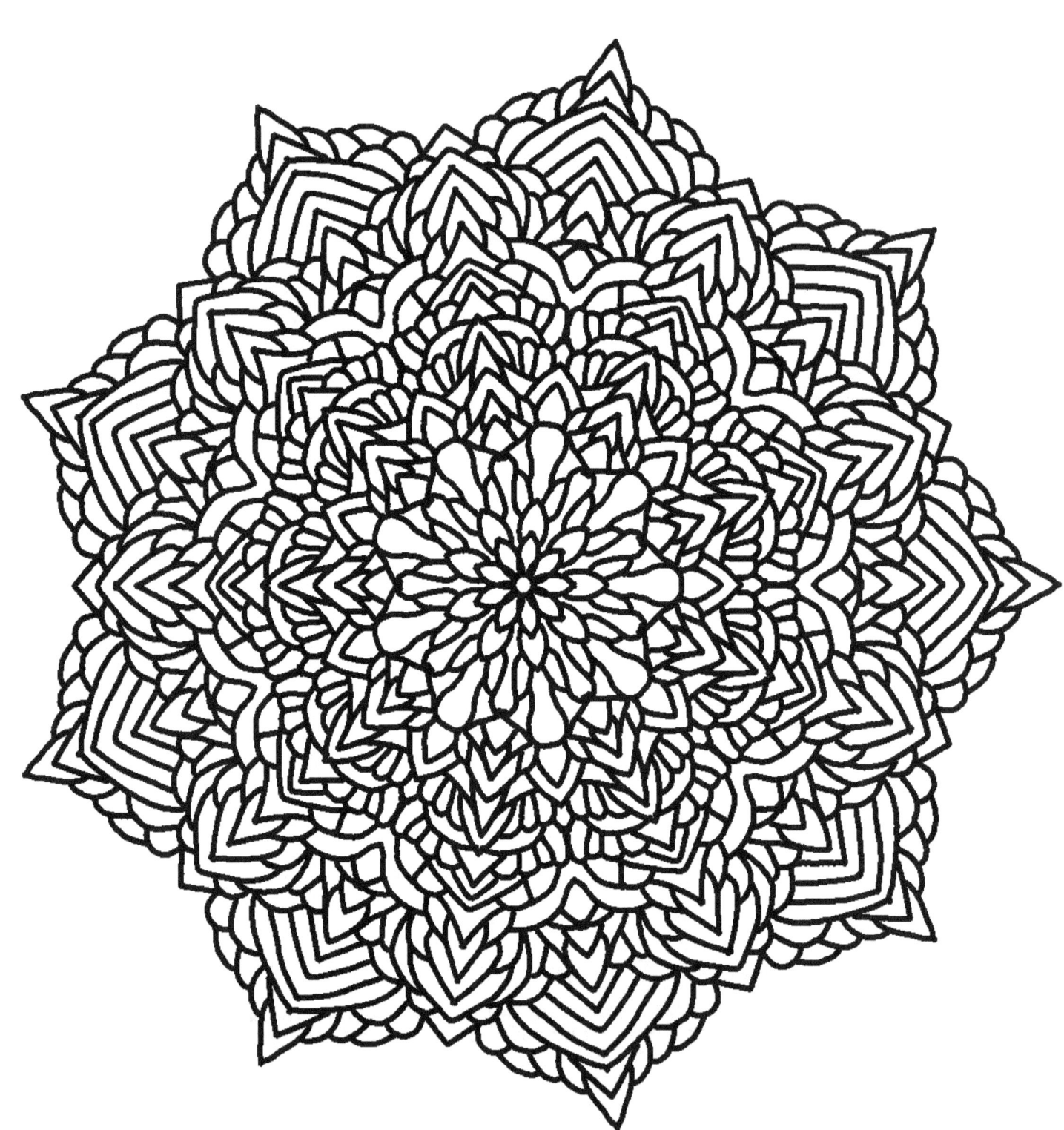

Chapter 2: Designs

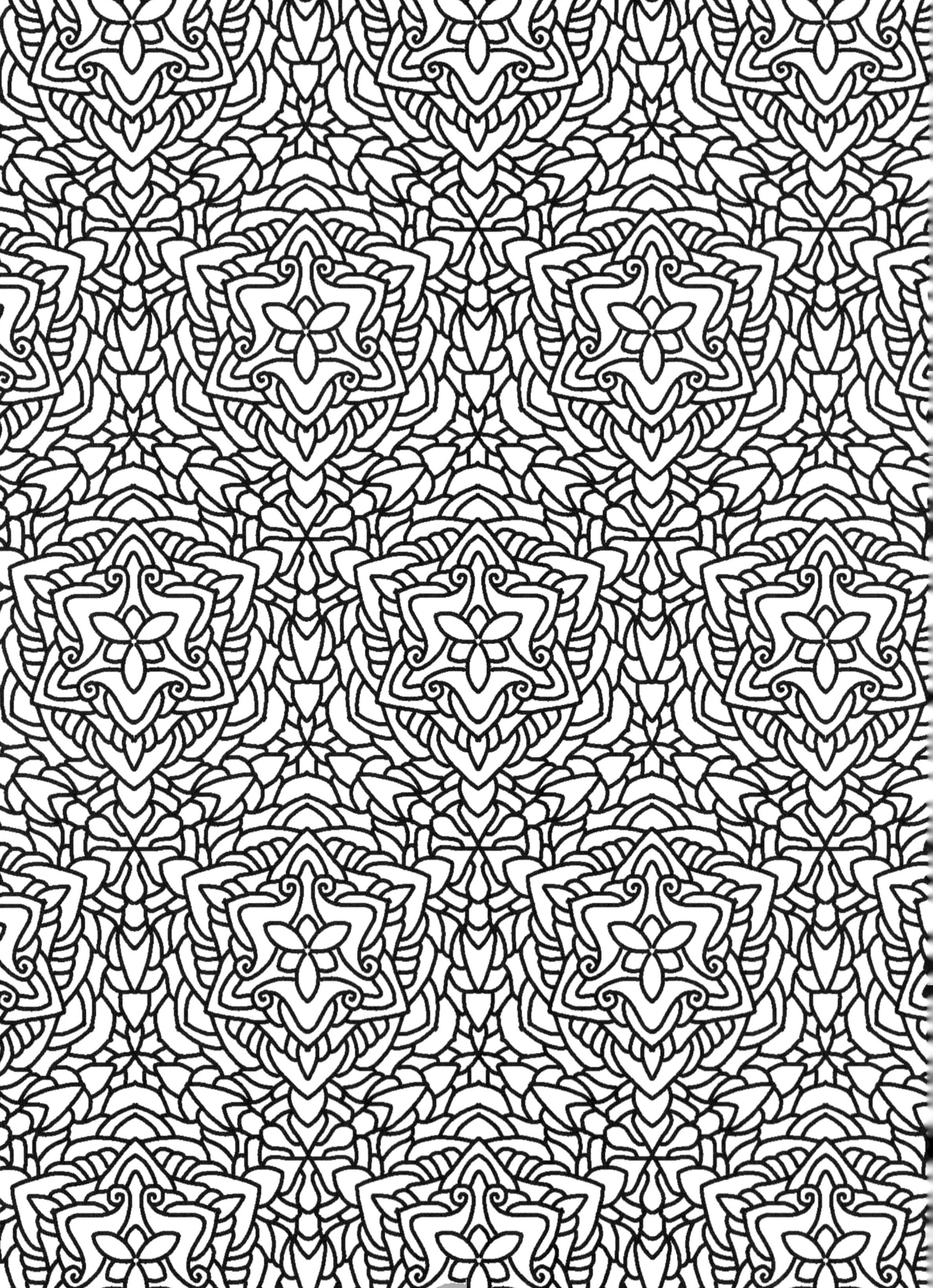

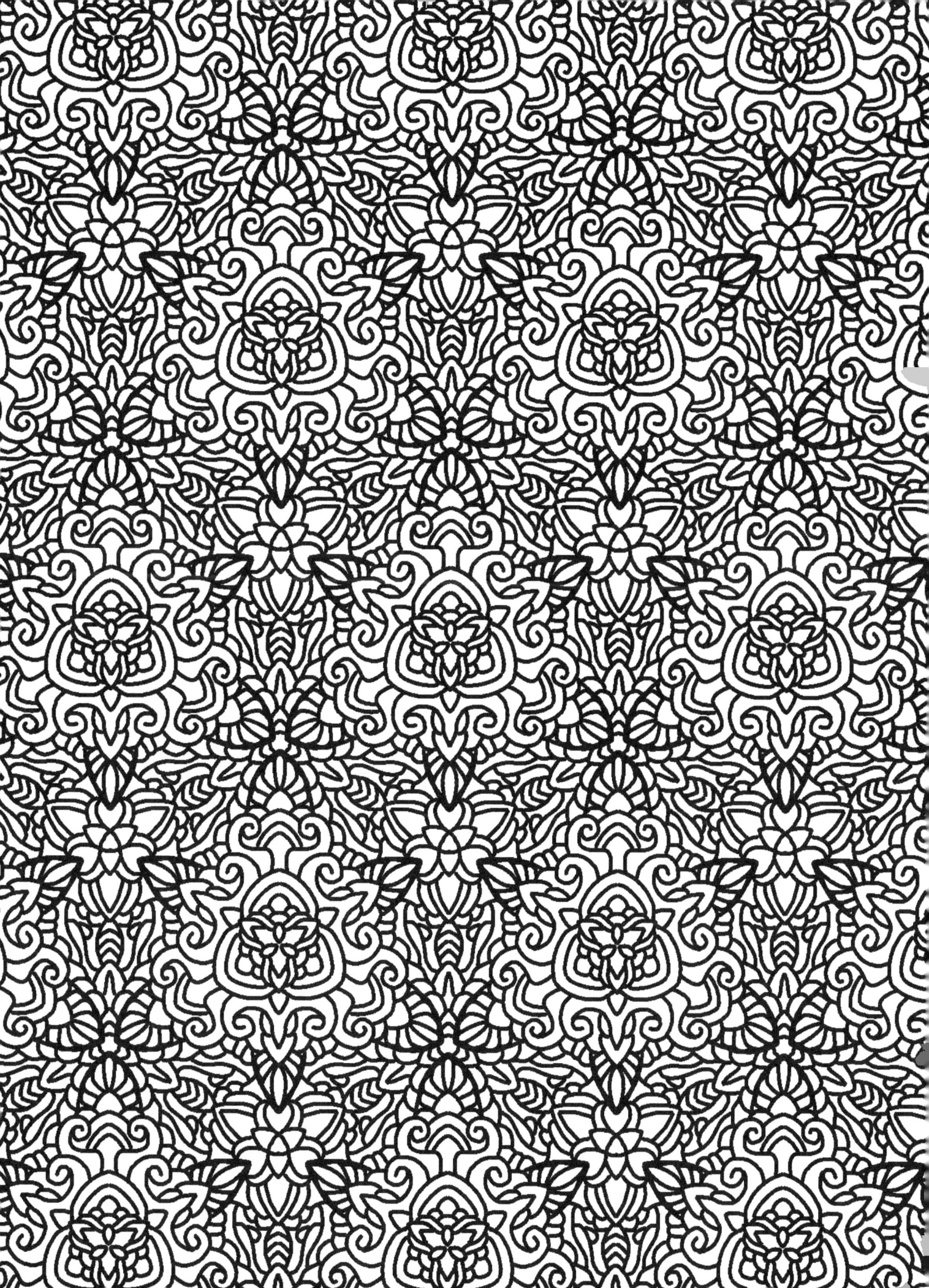

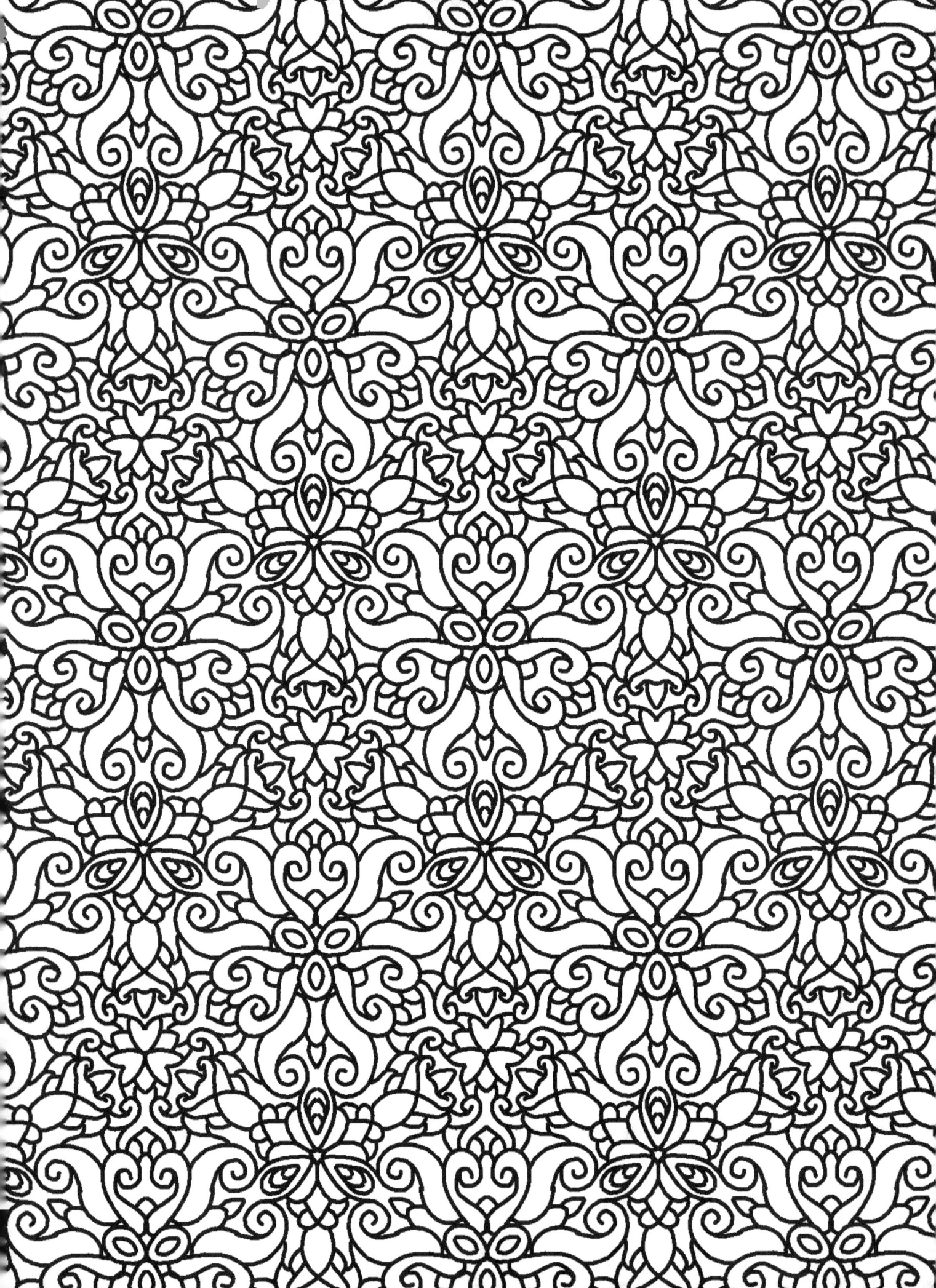

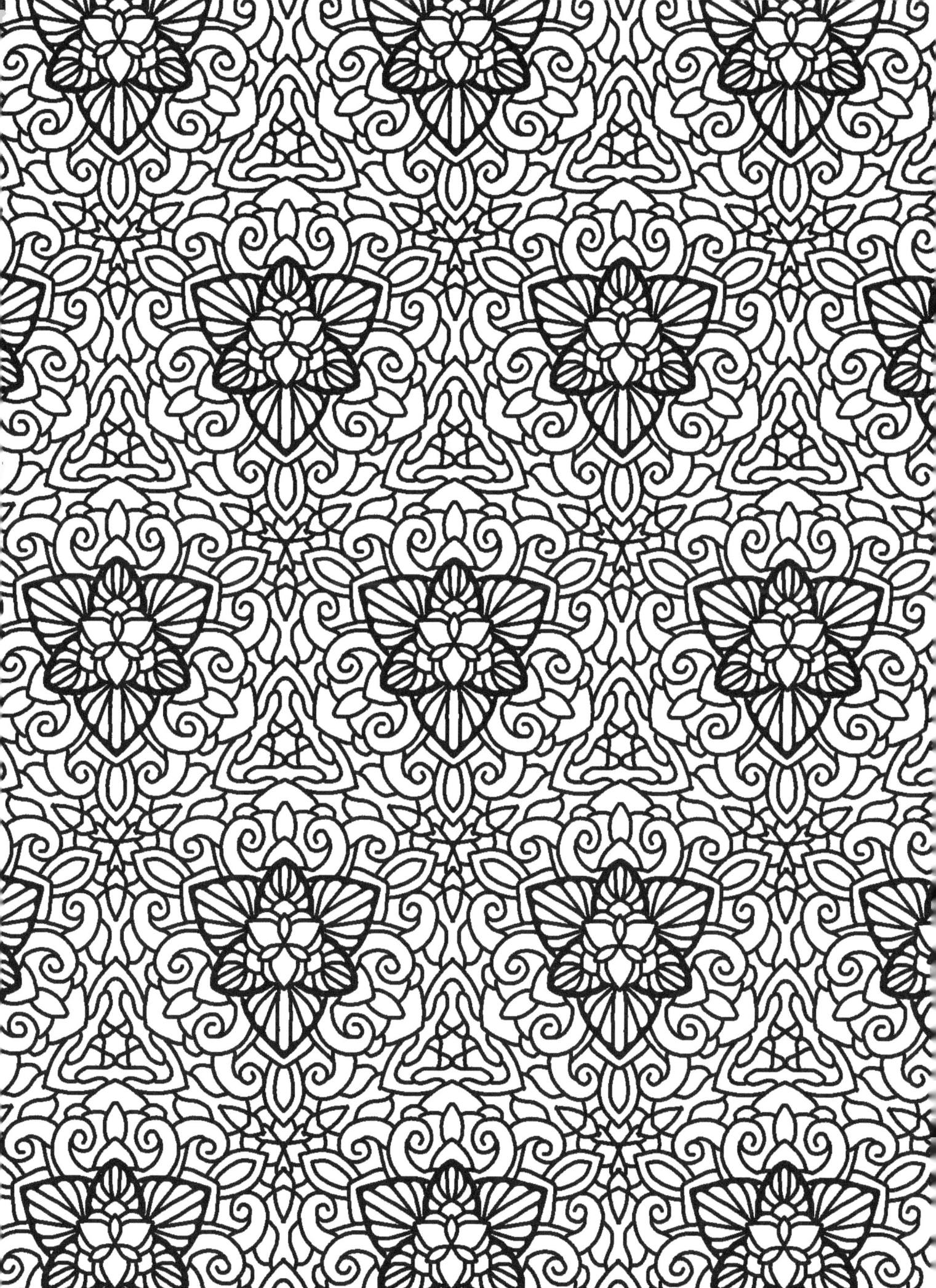

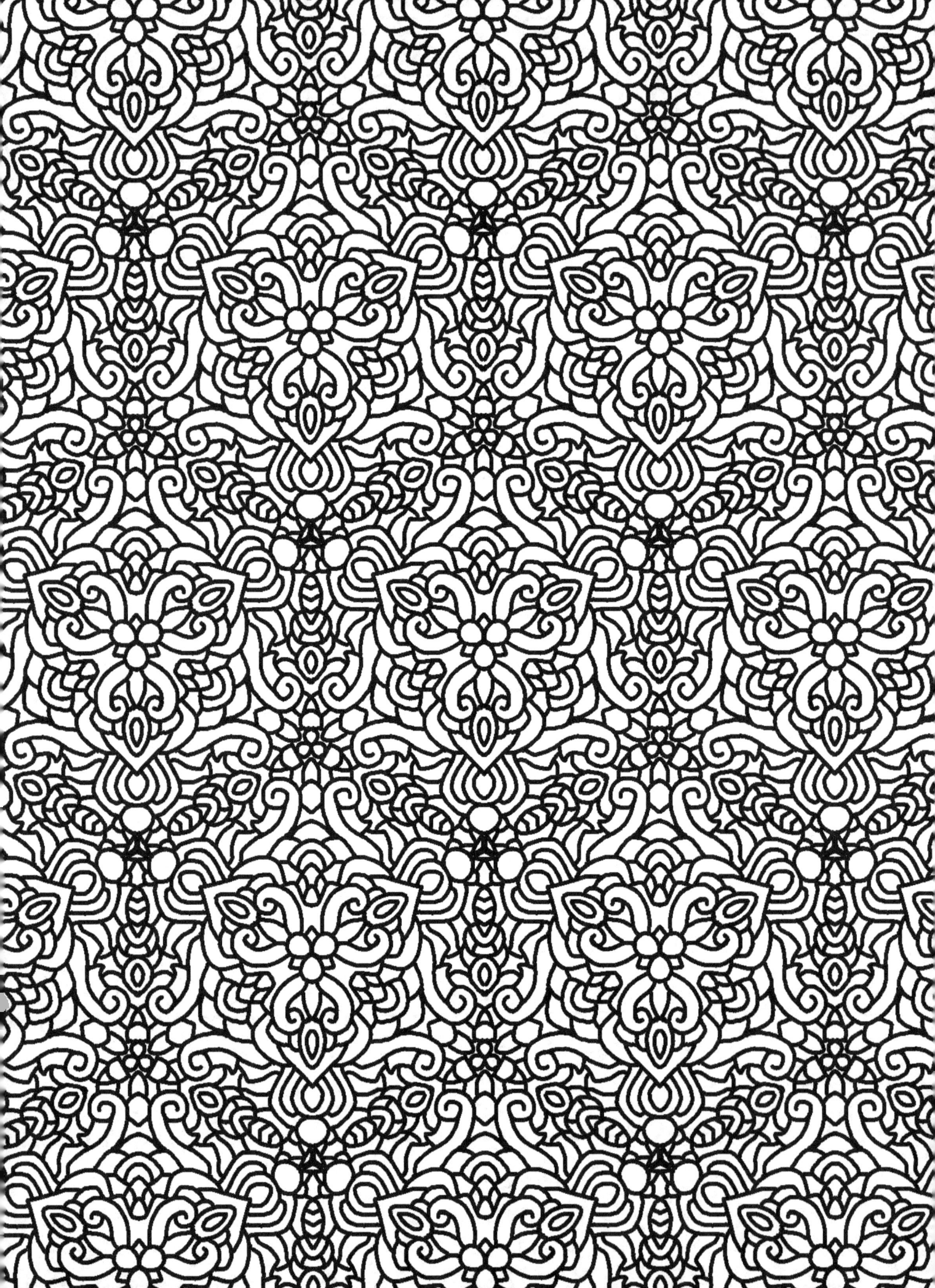

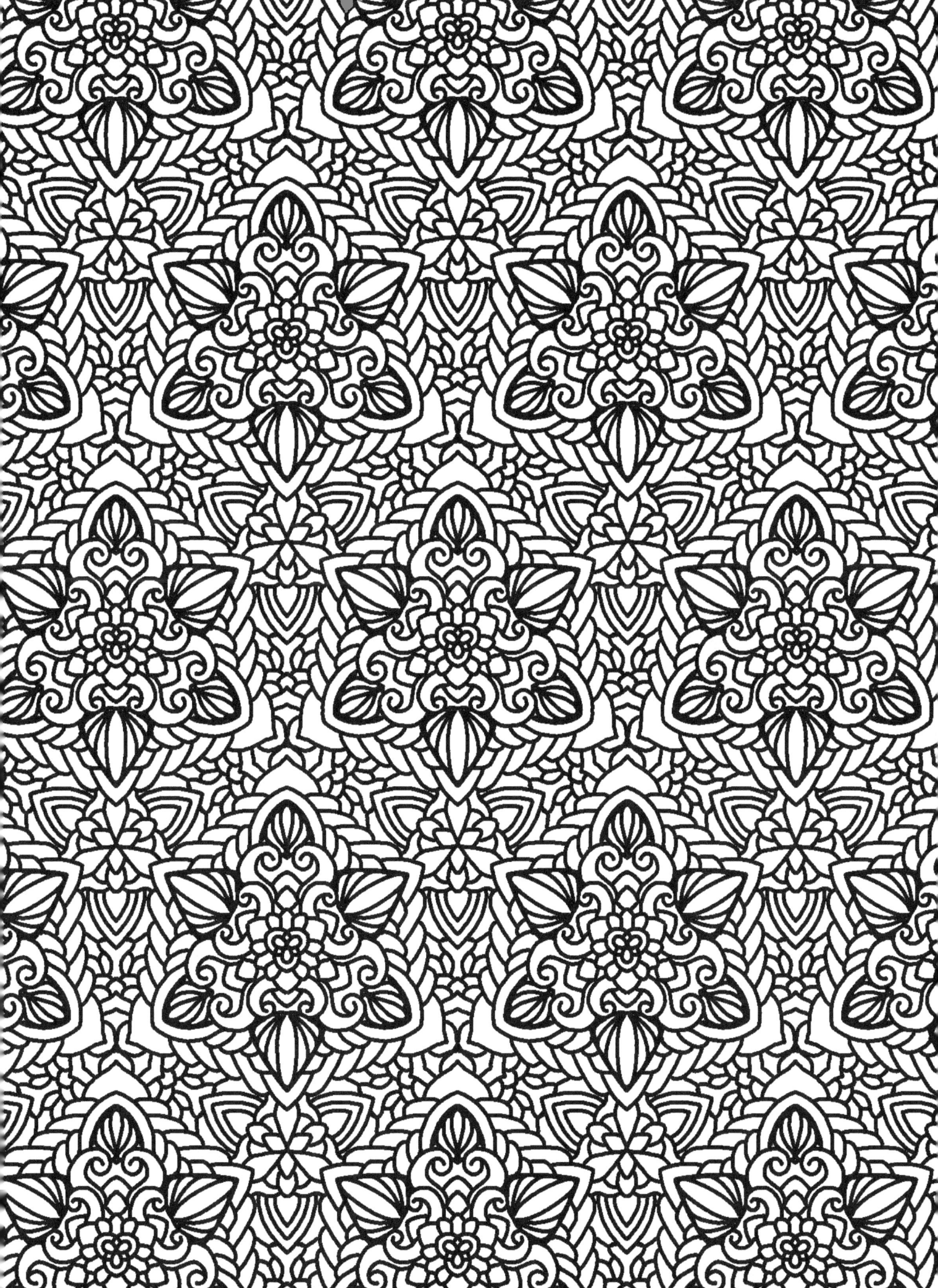

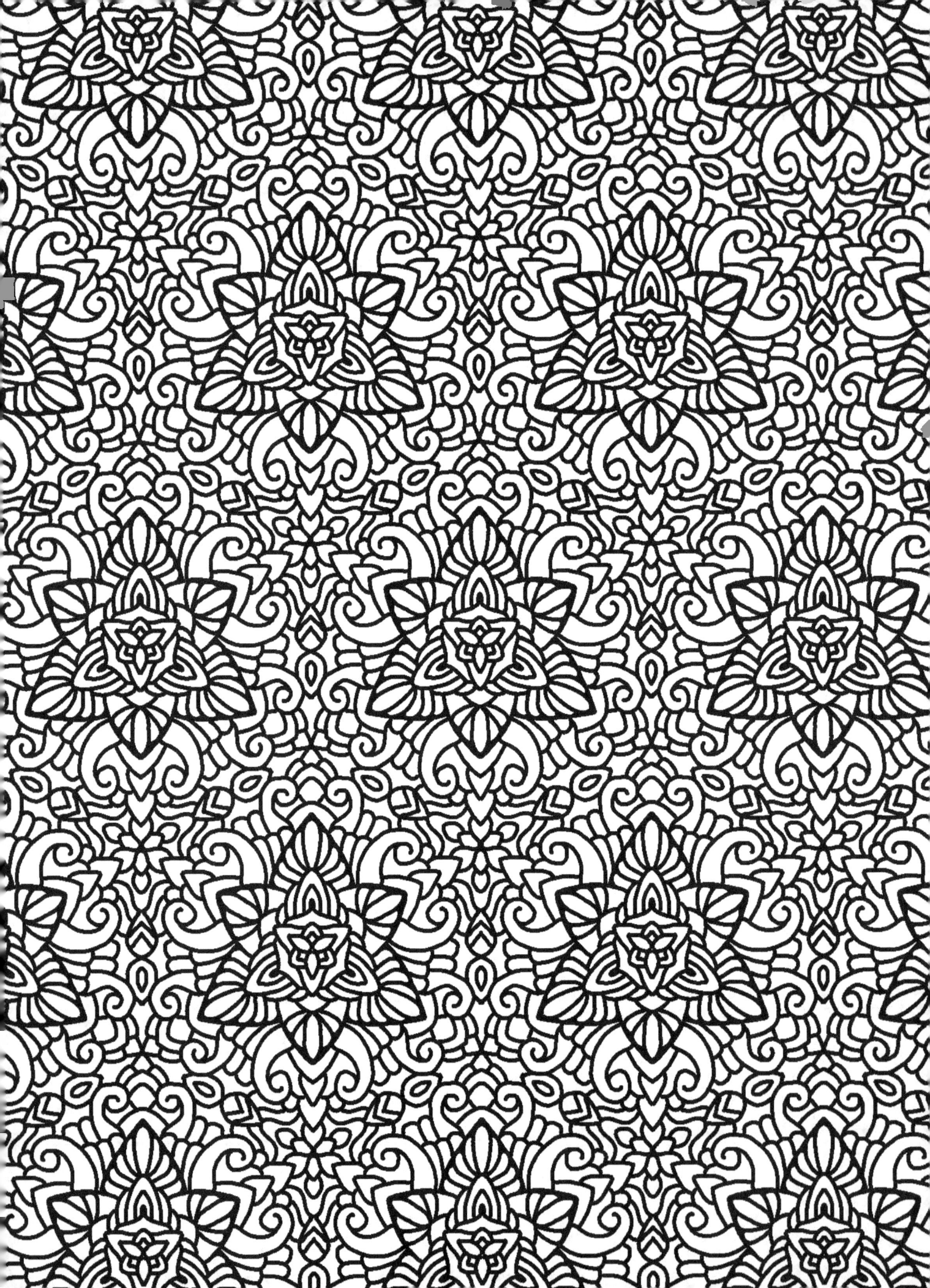

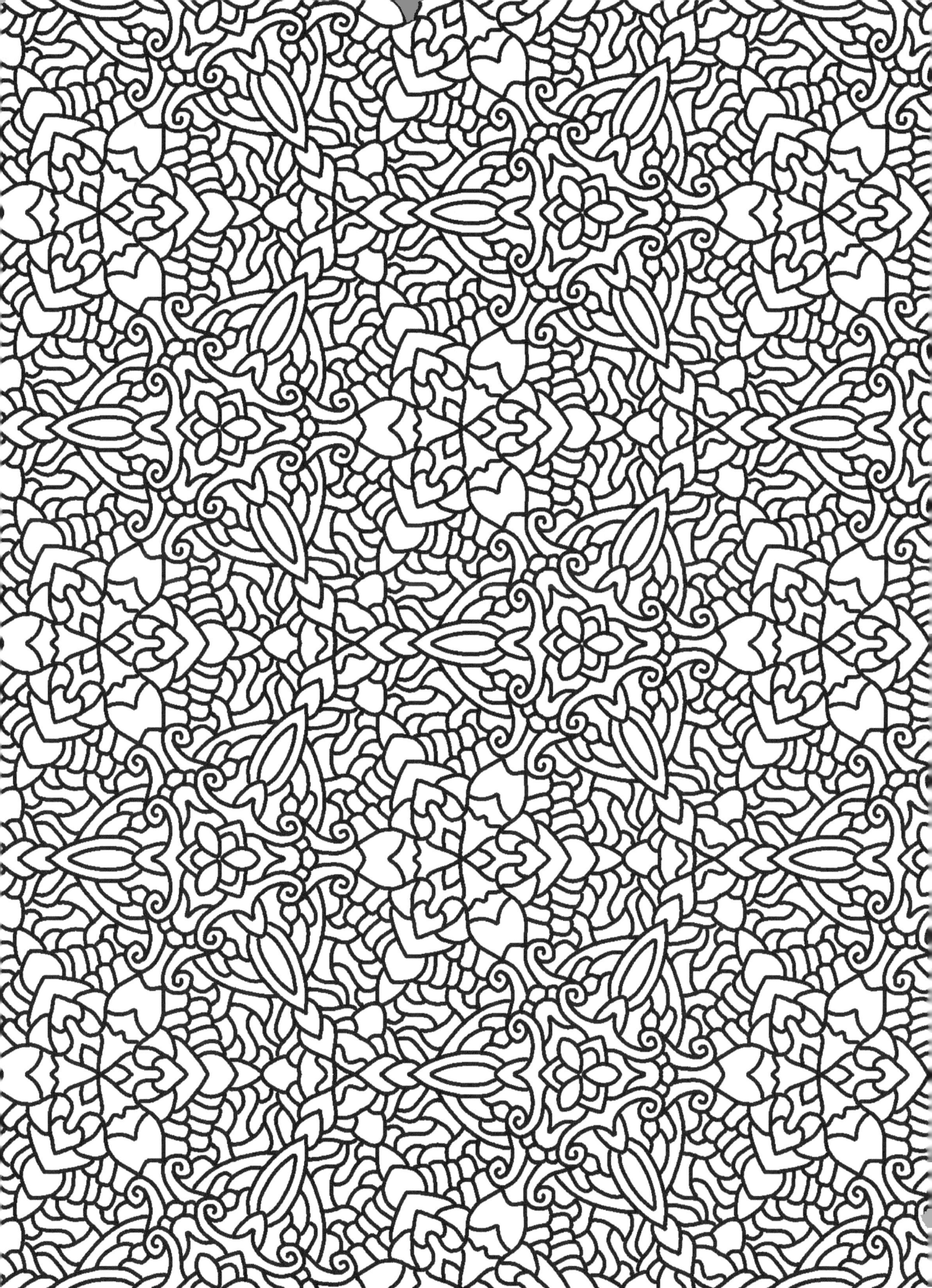

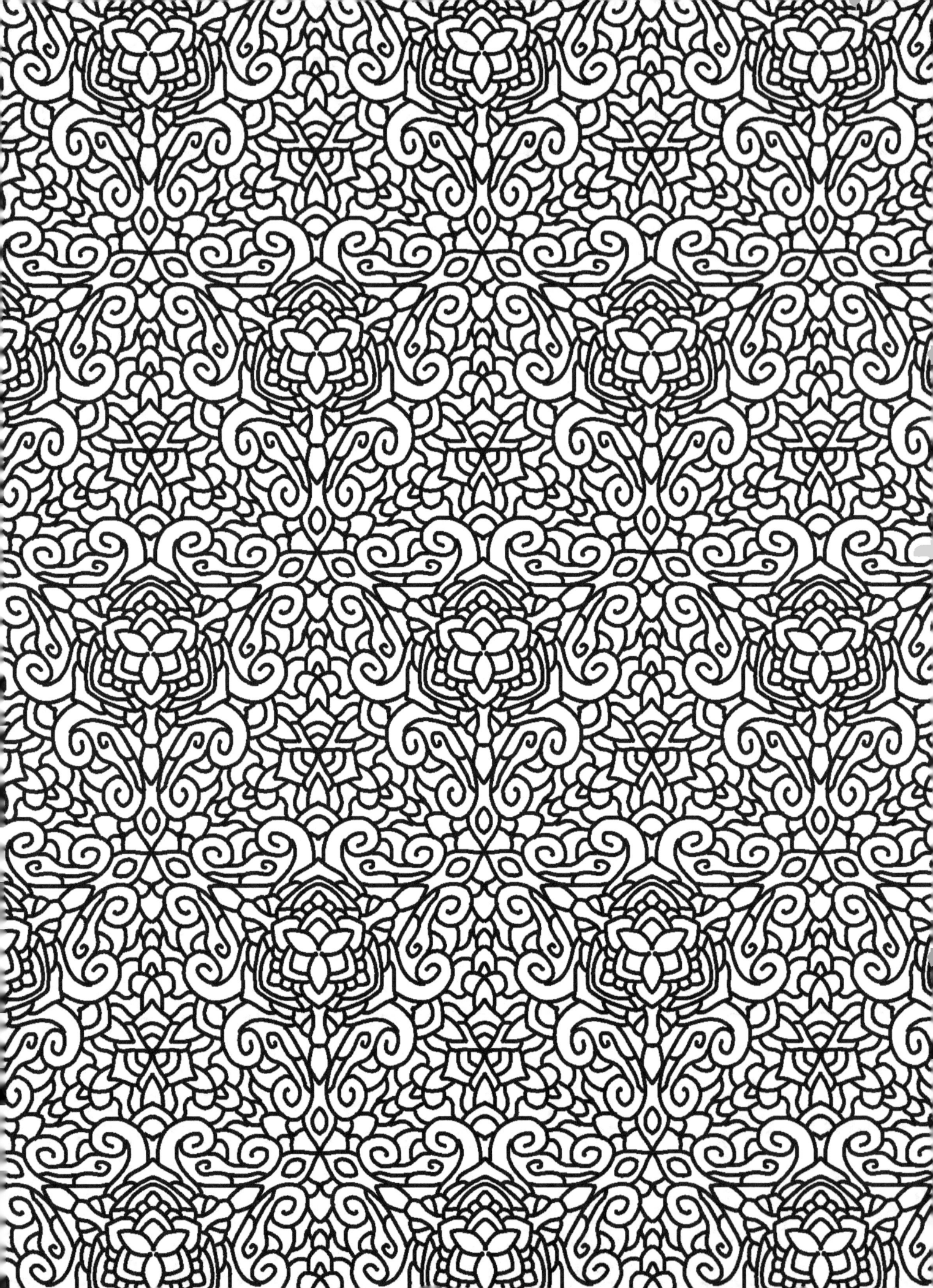

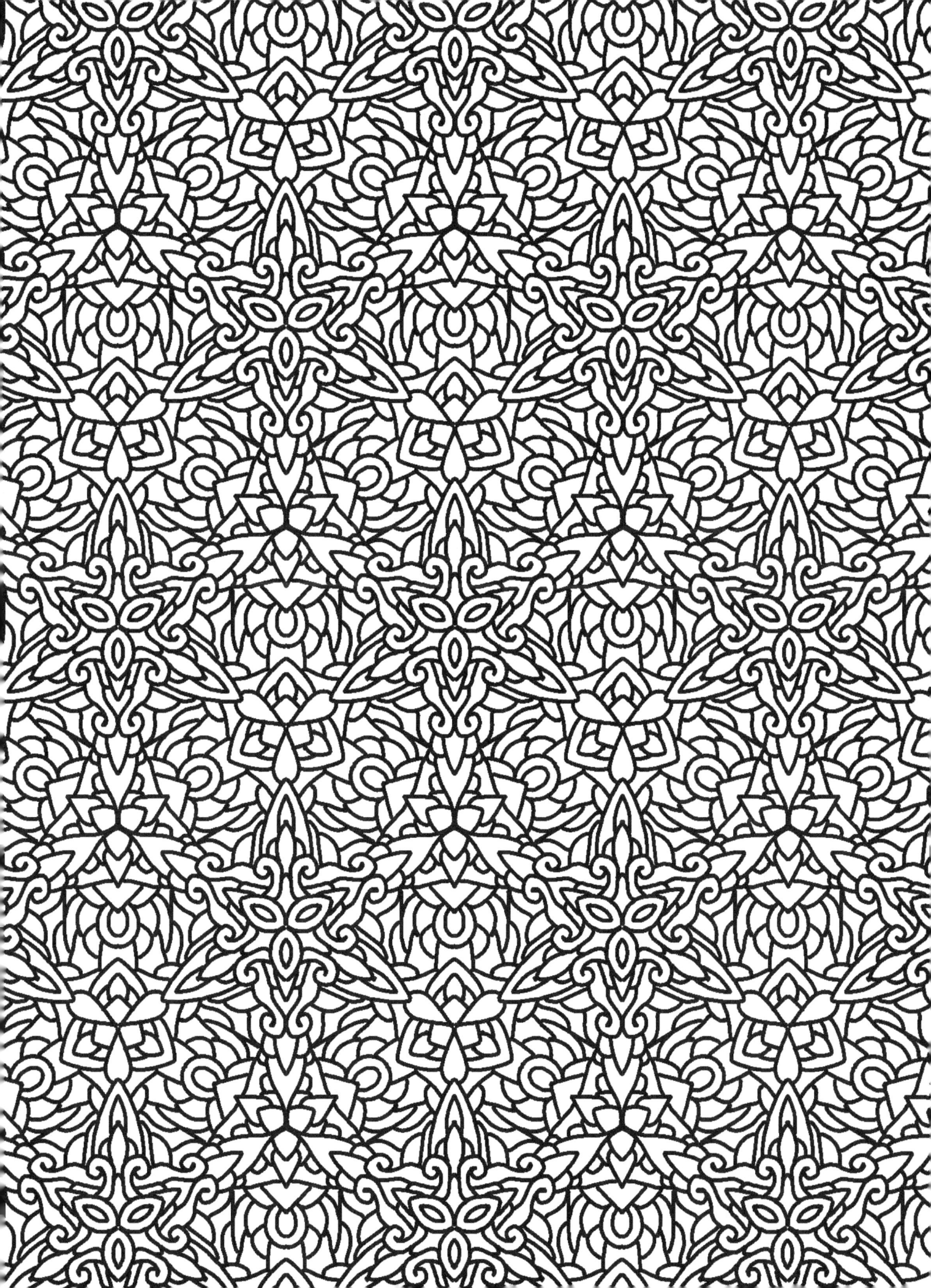

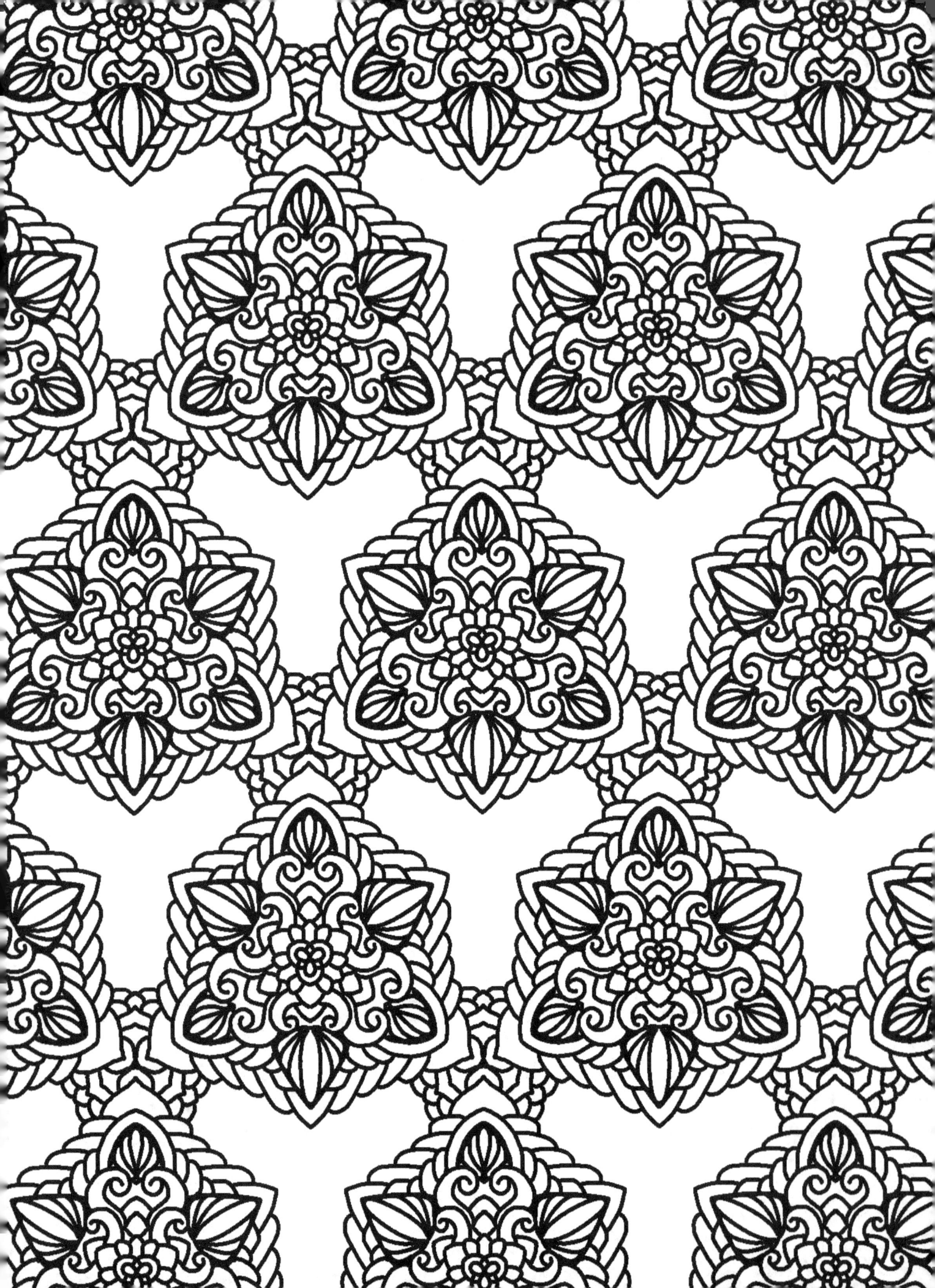

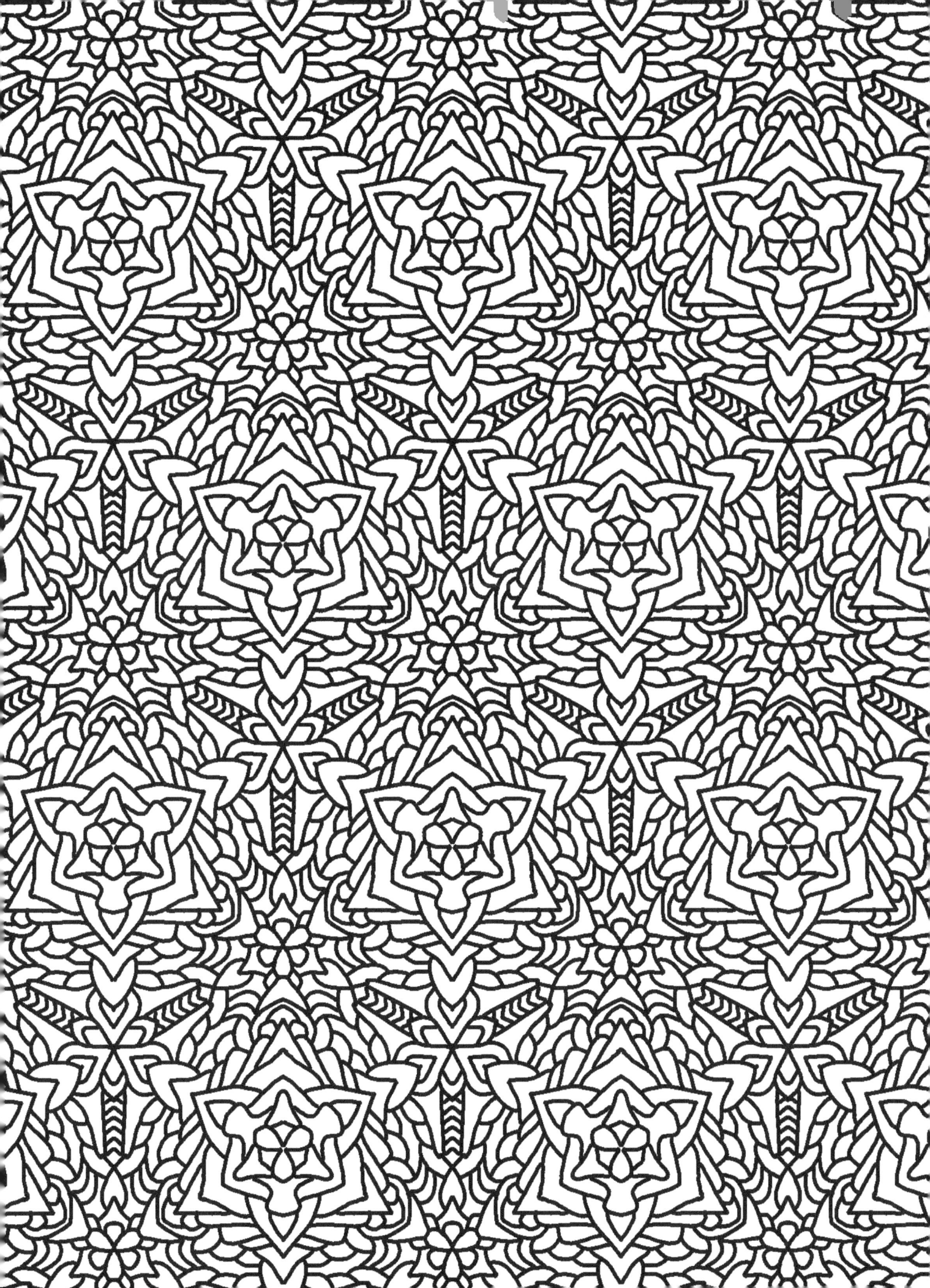

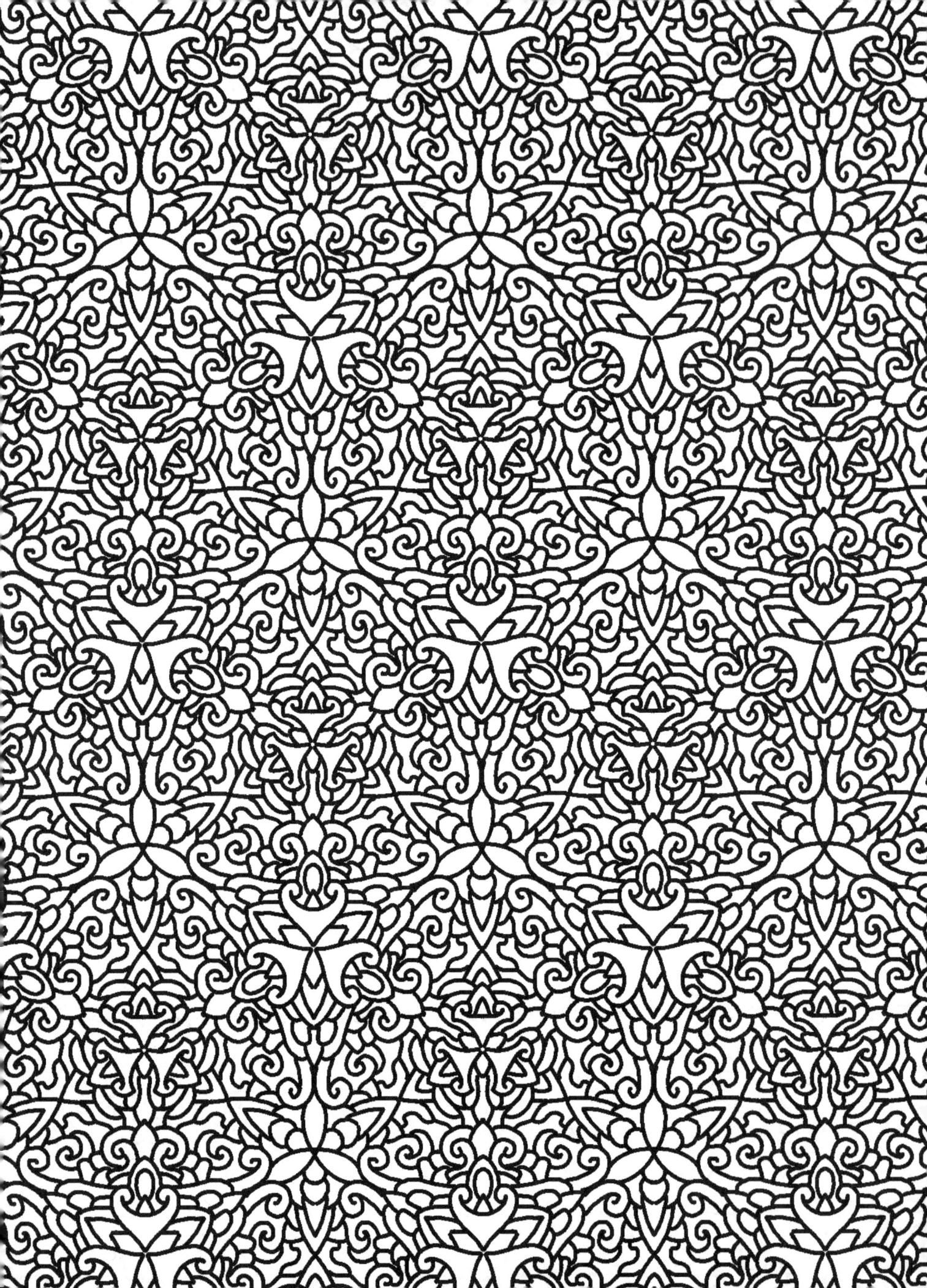

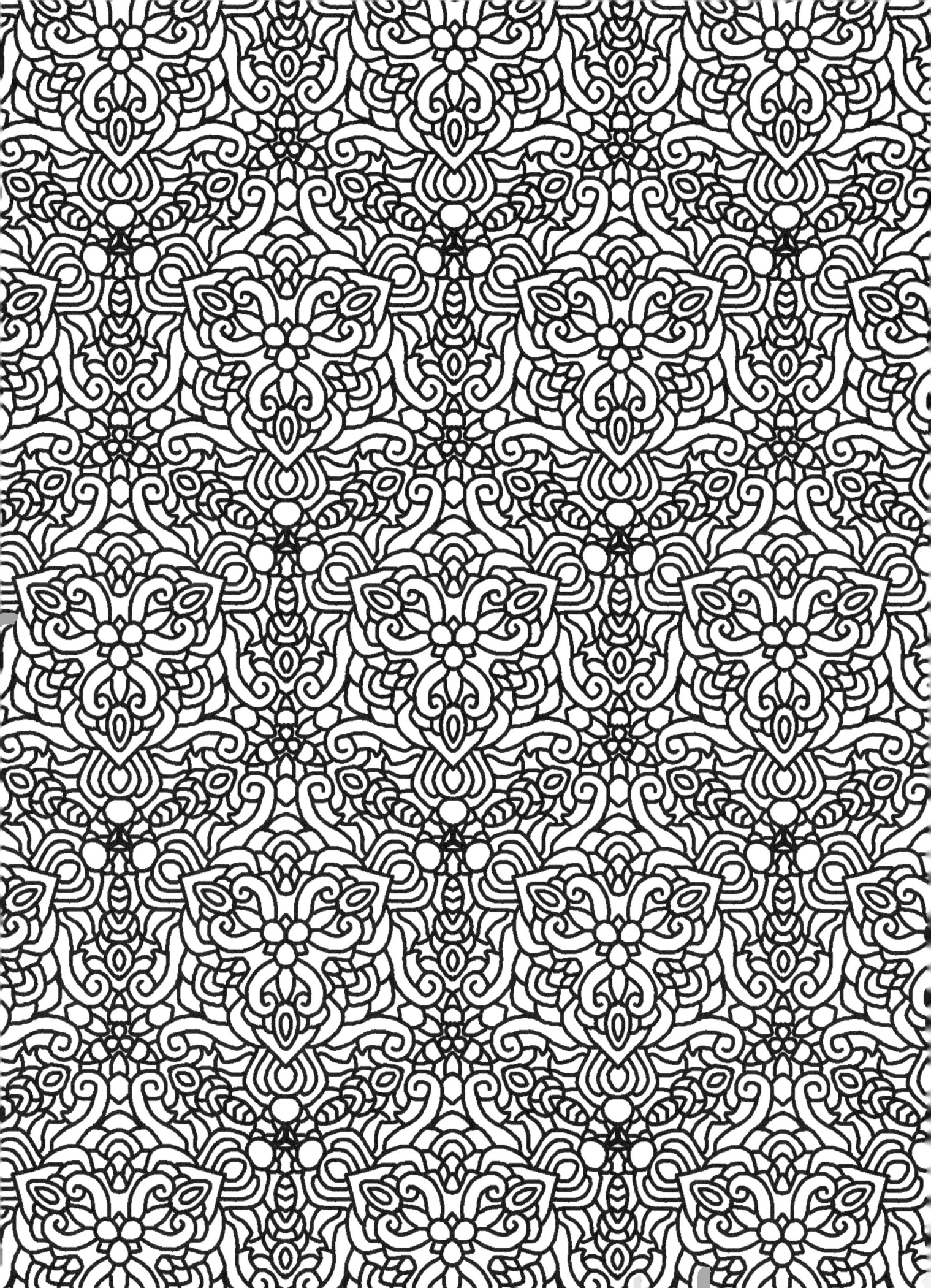

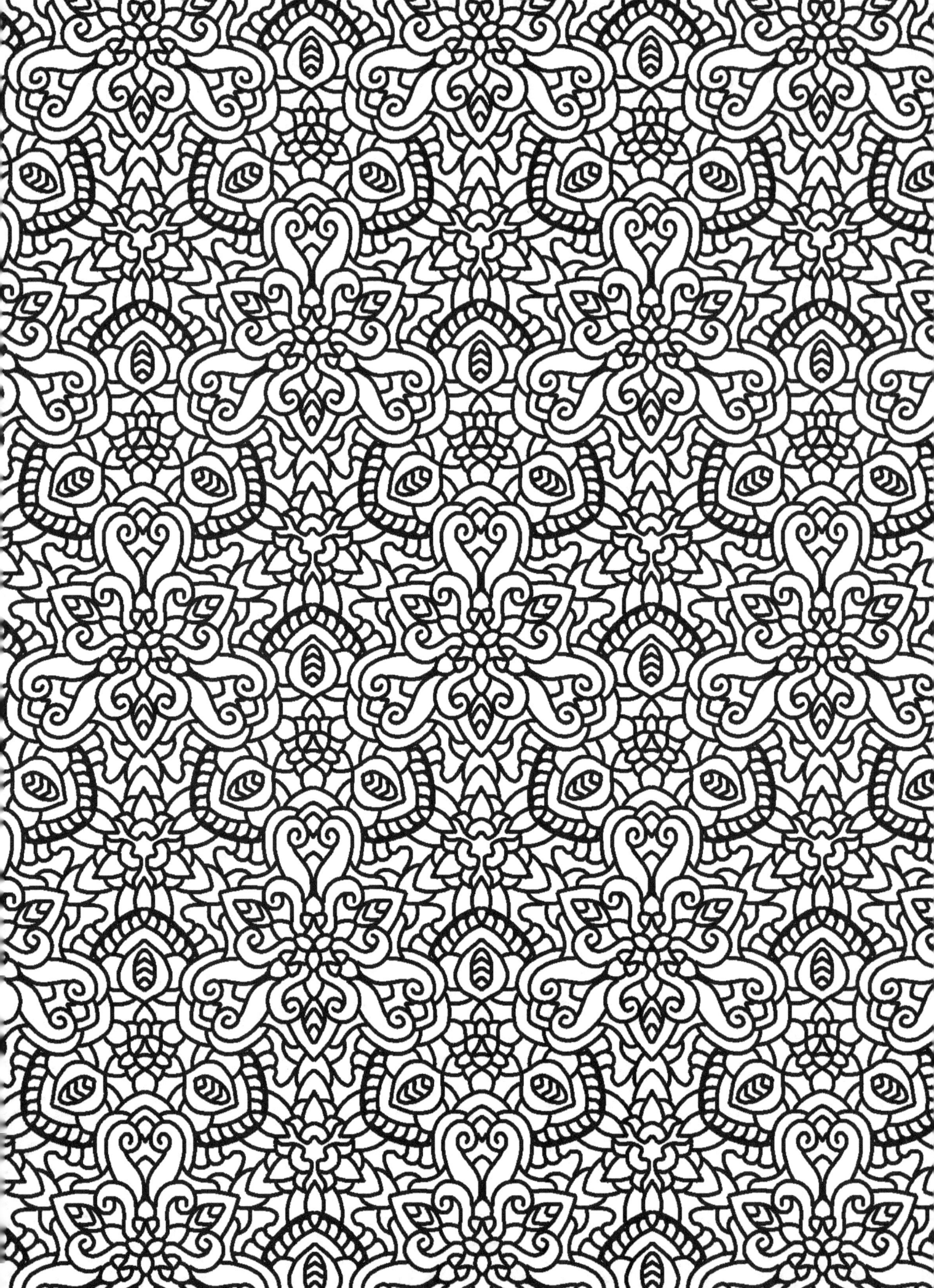

Chapter 3: Maximum Design

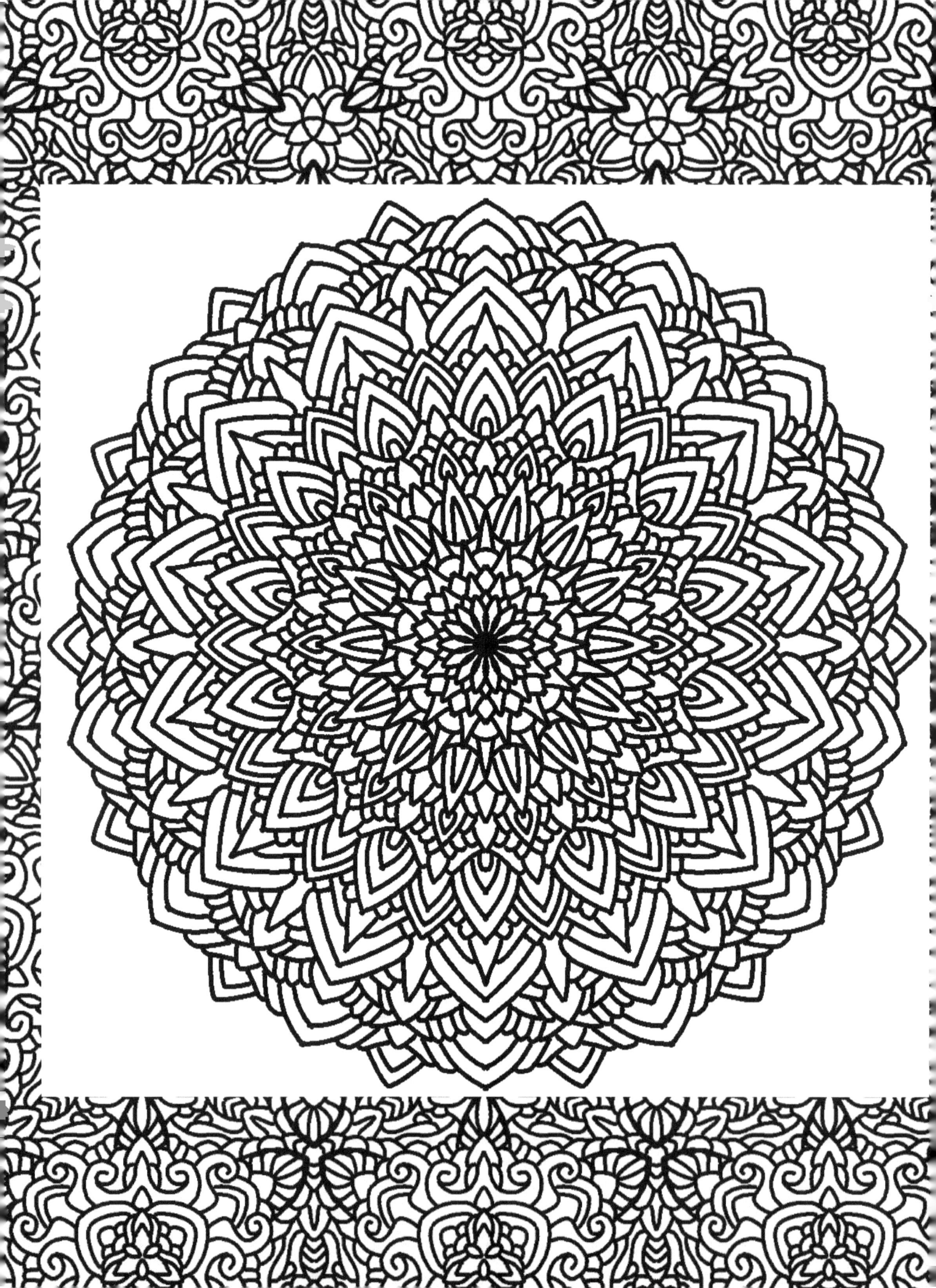

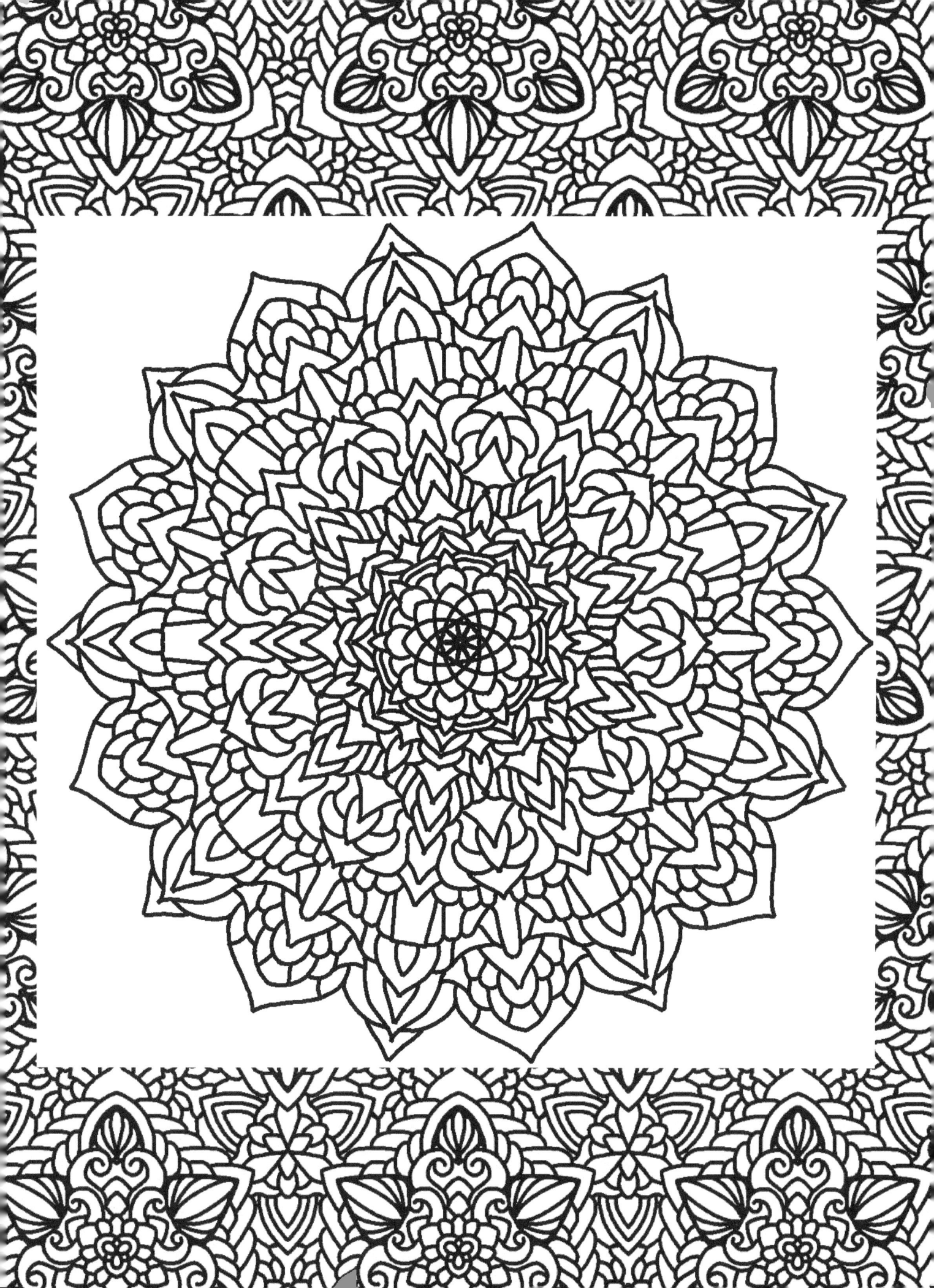

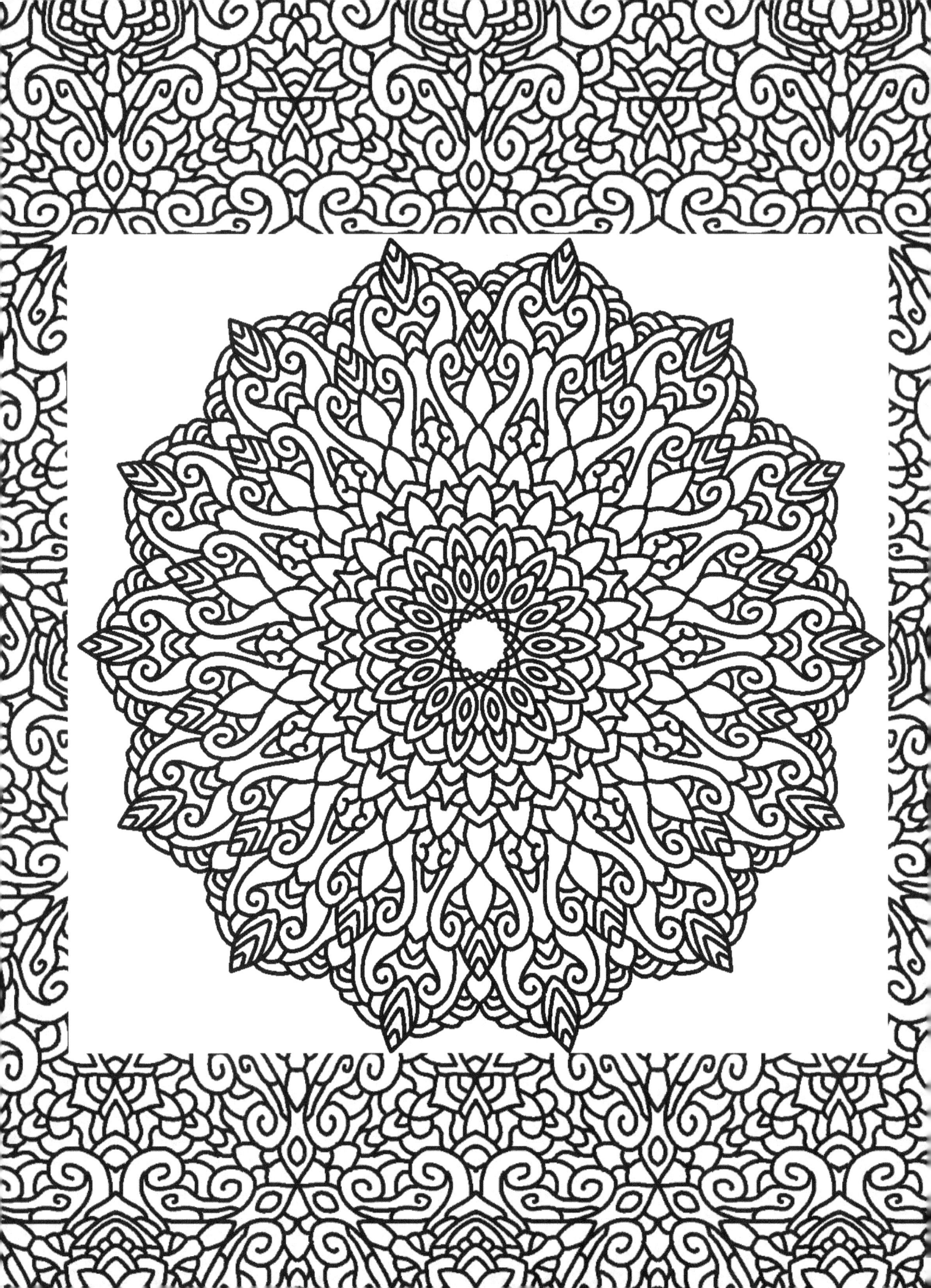

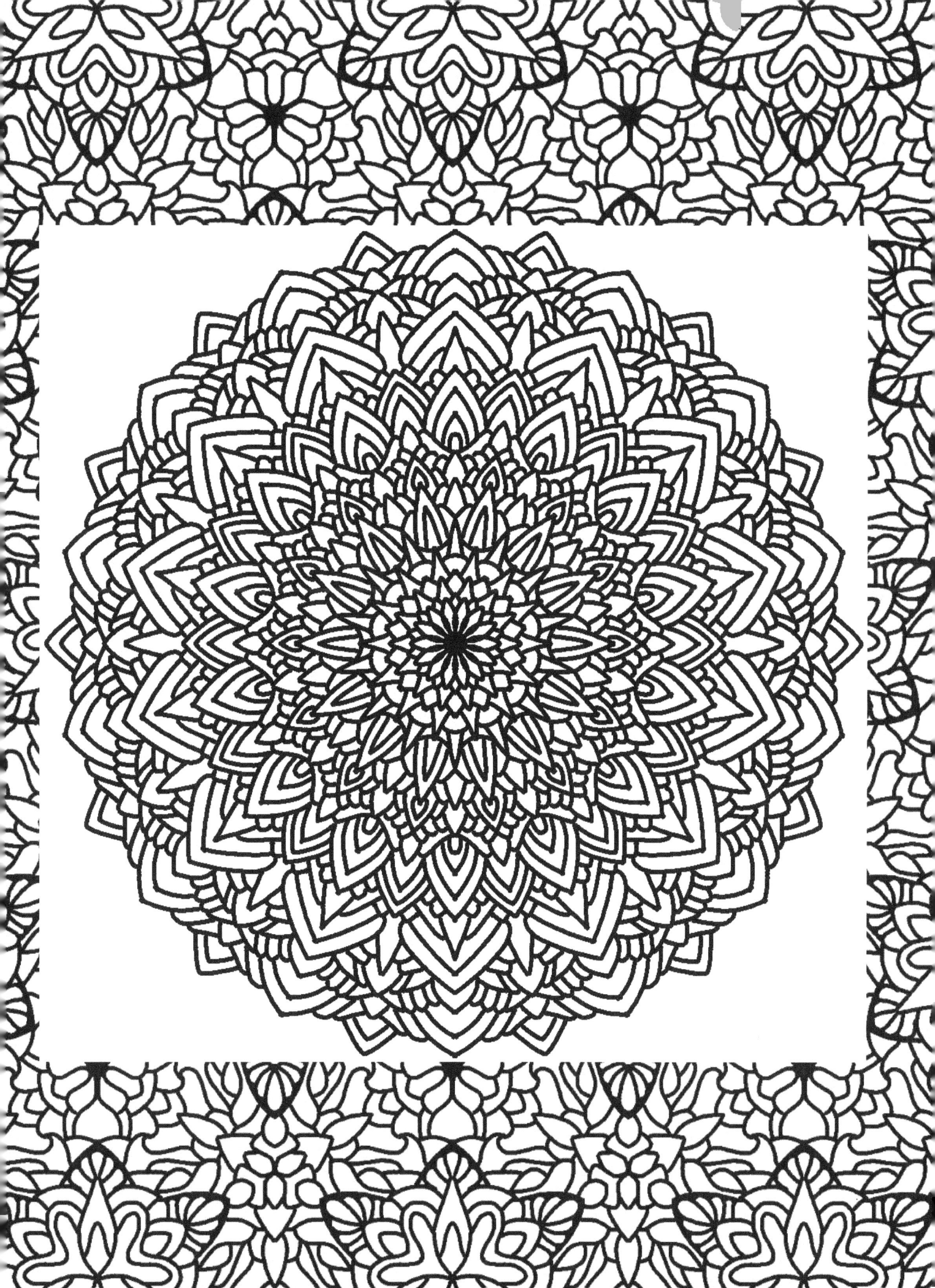

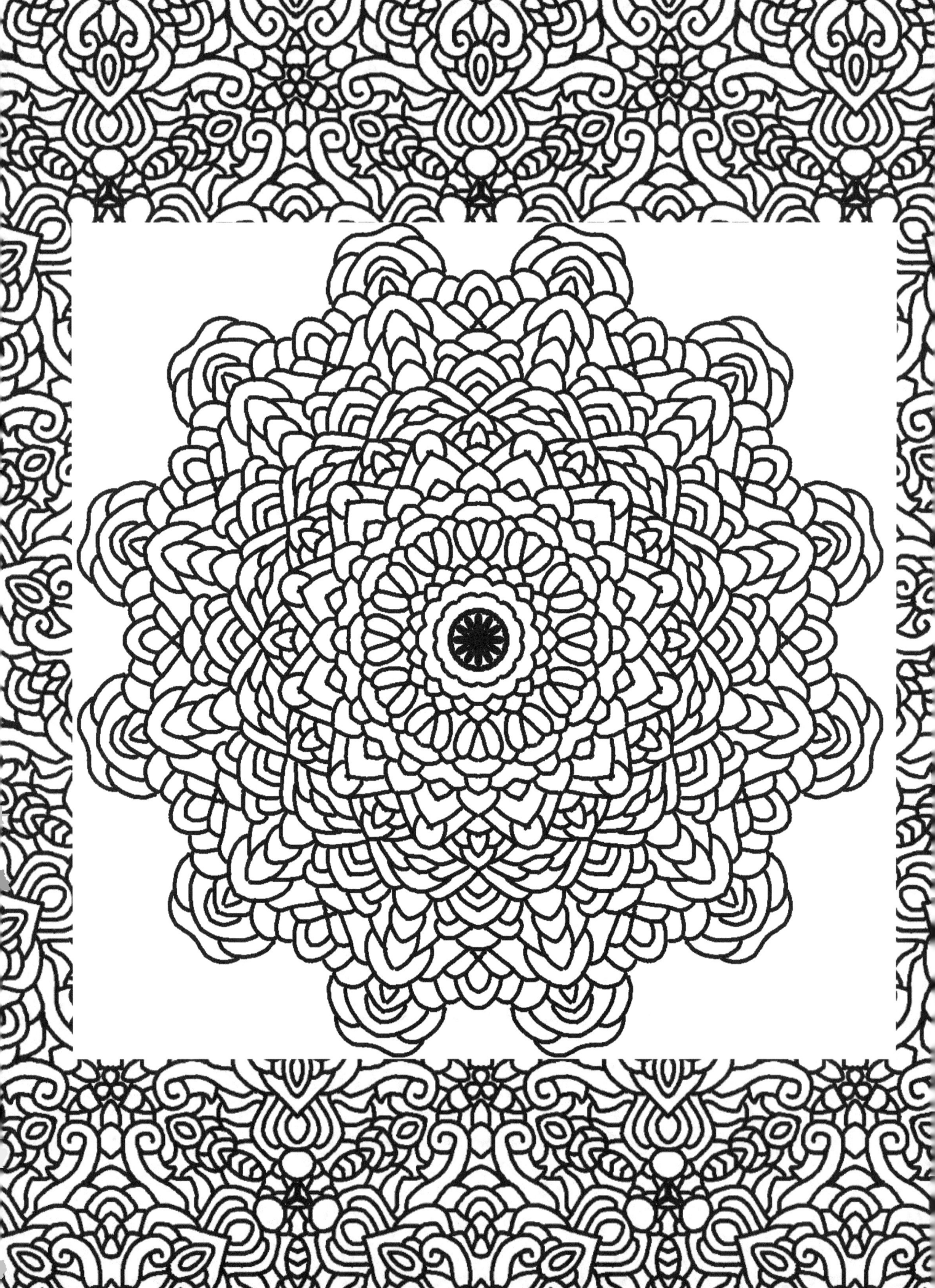

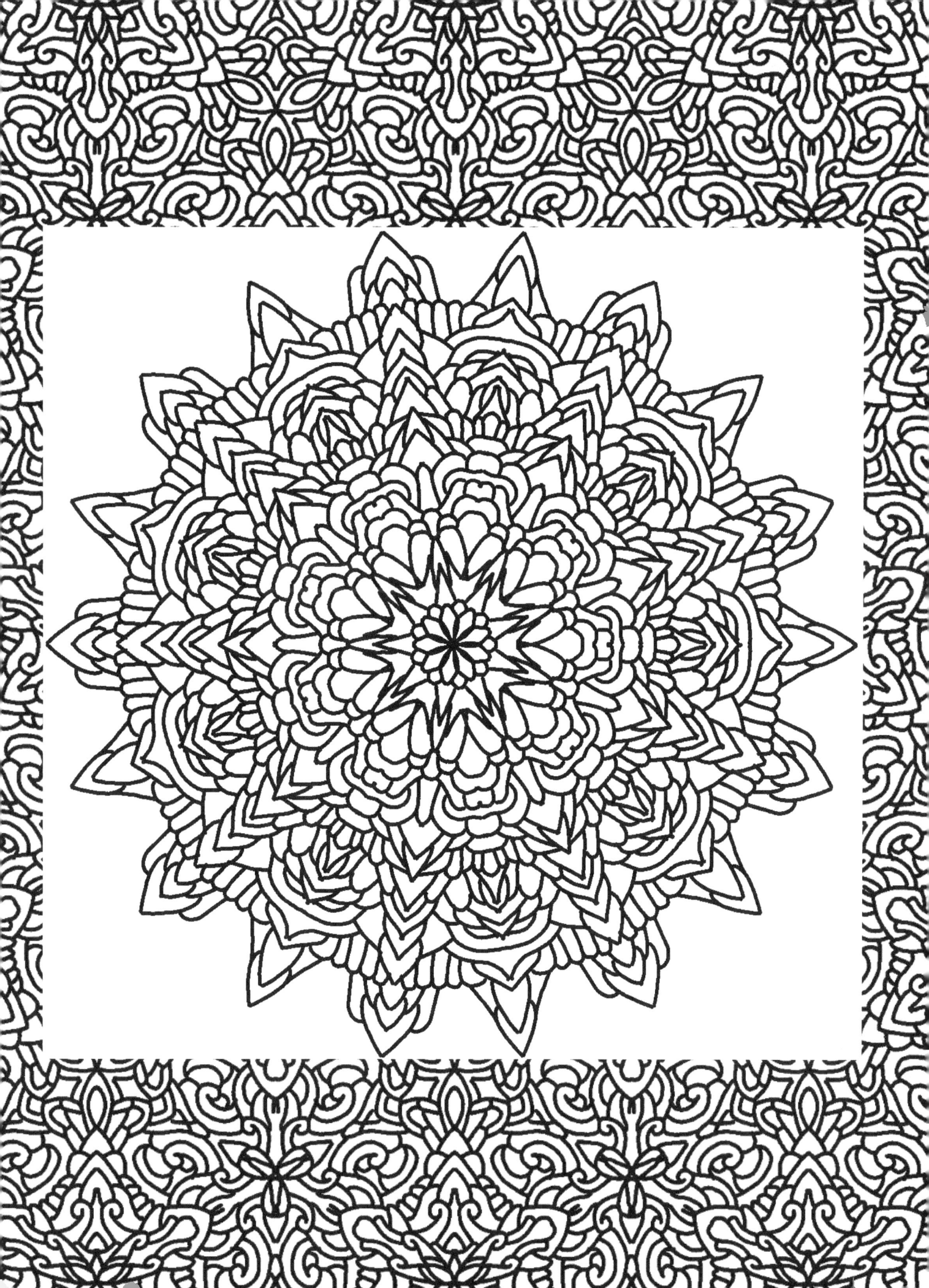

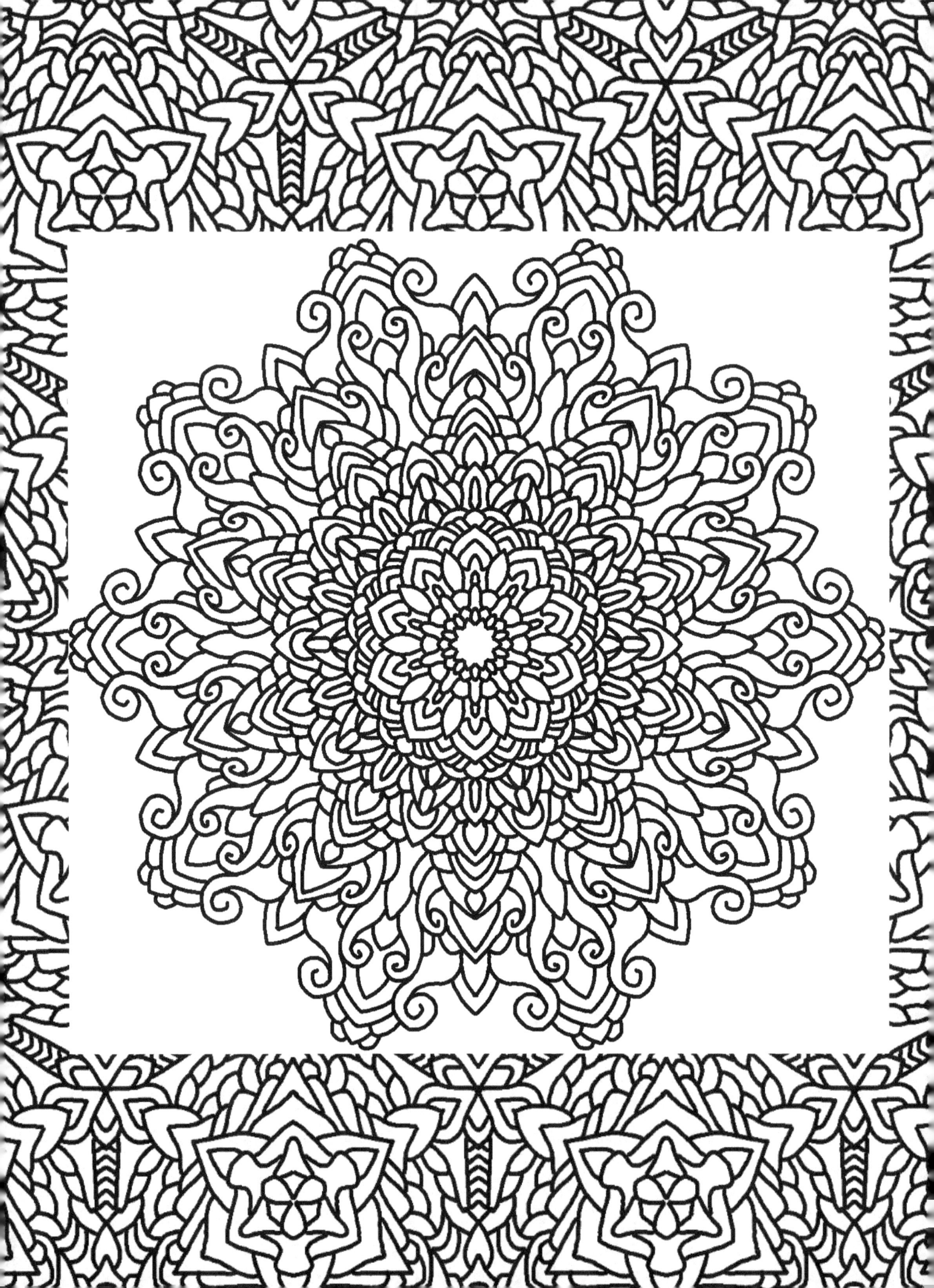

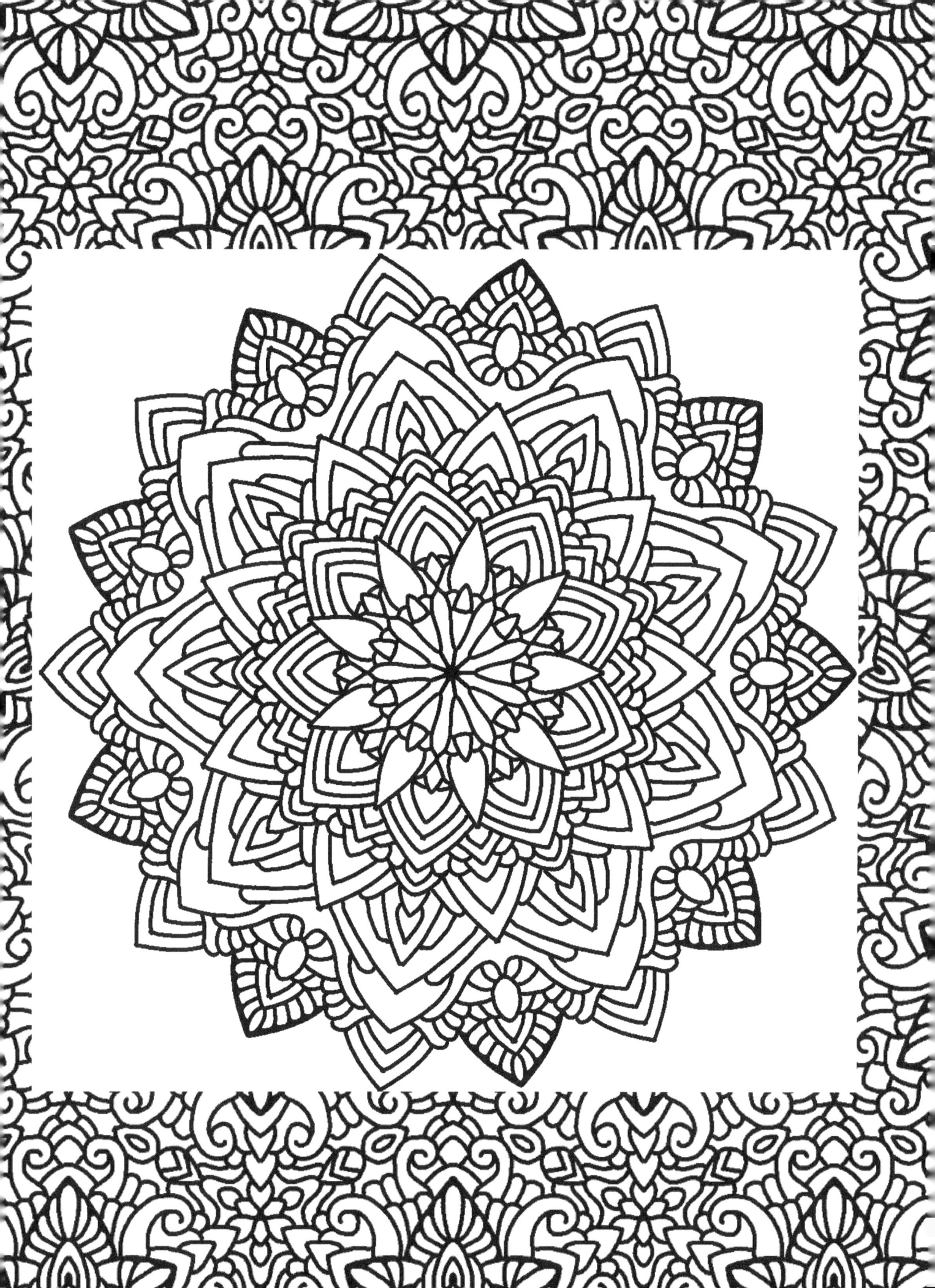

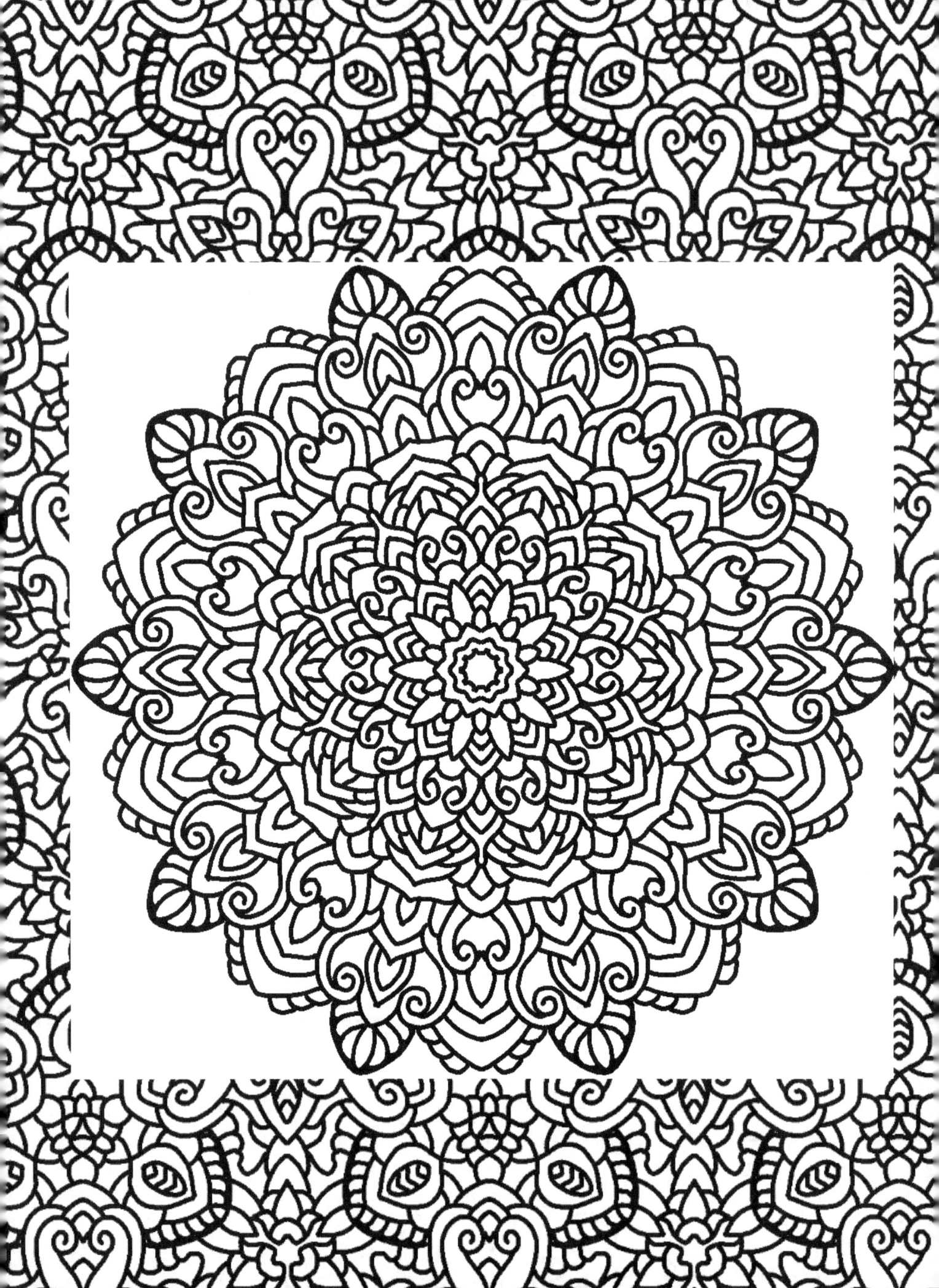

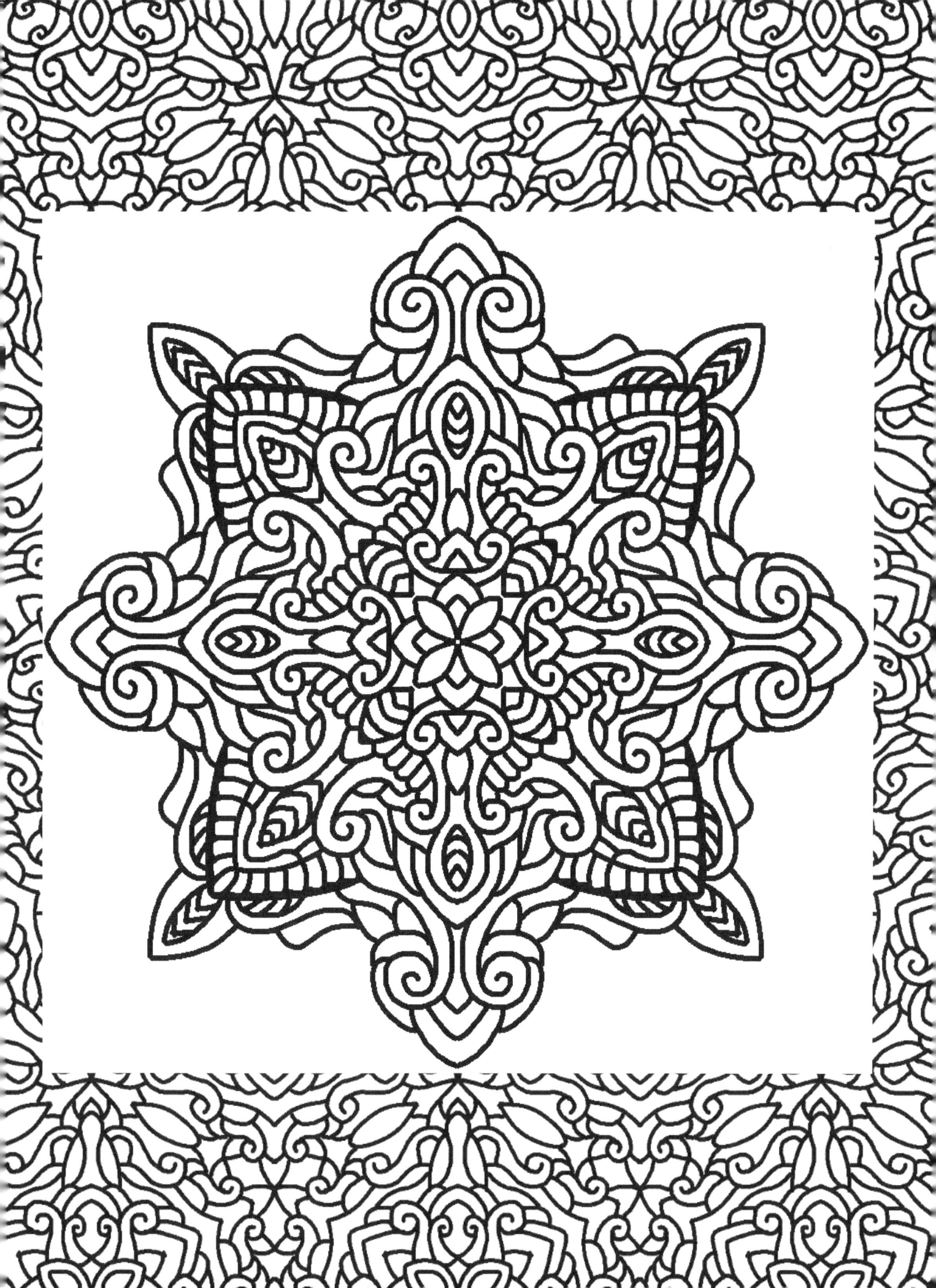

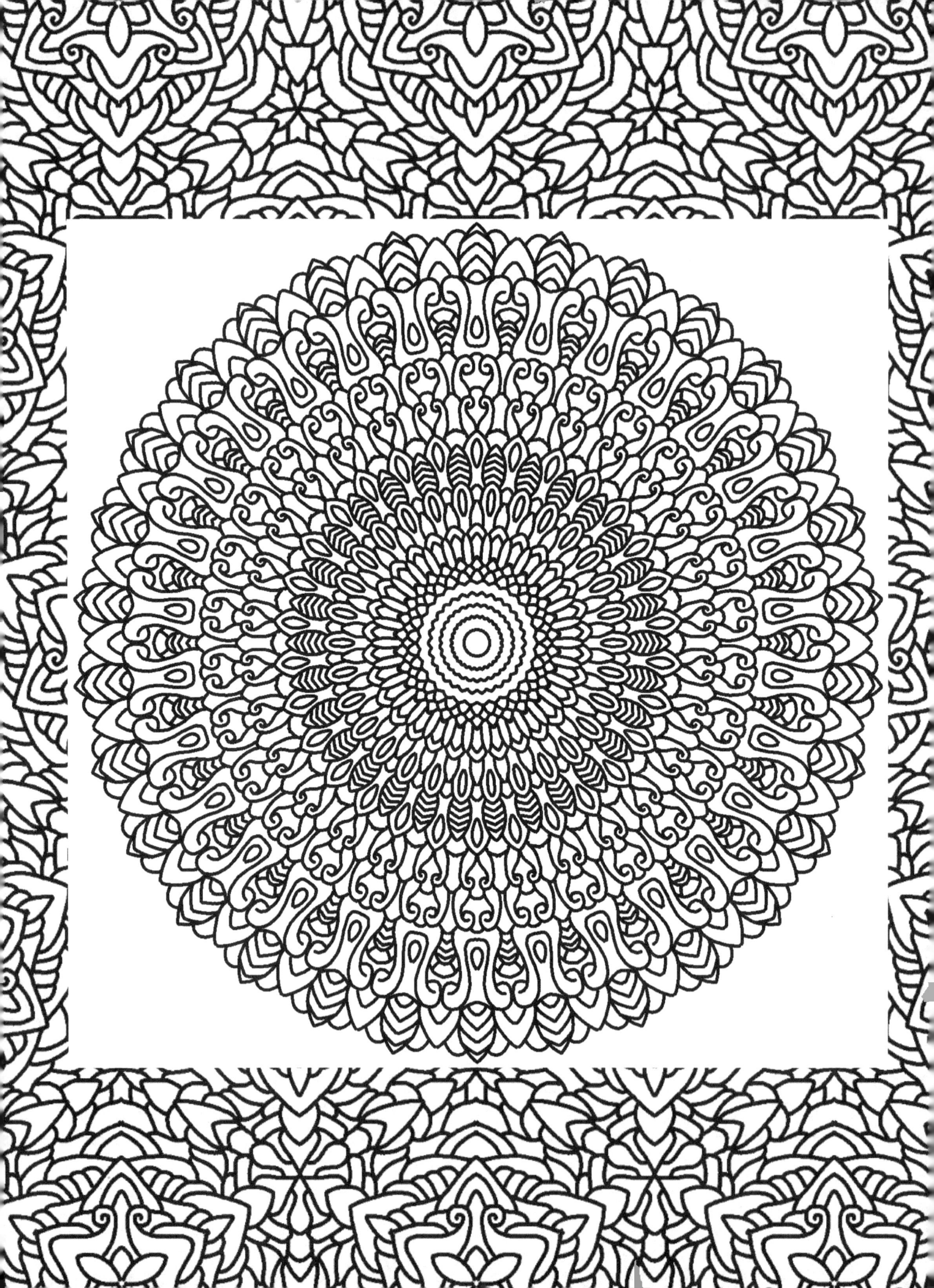

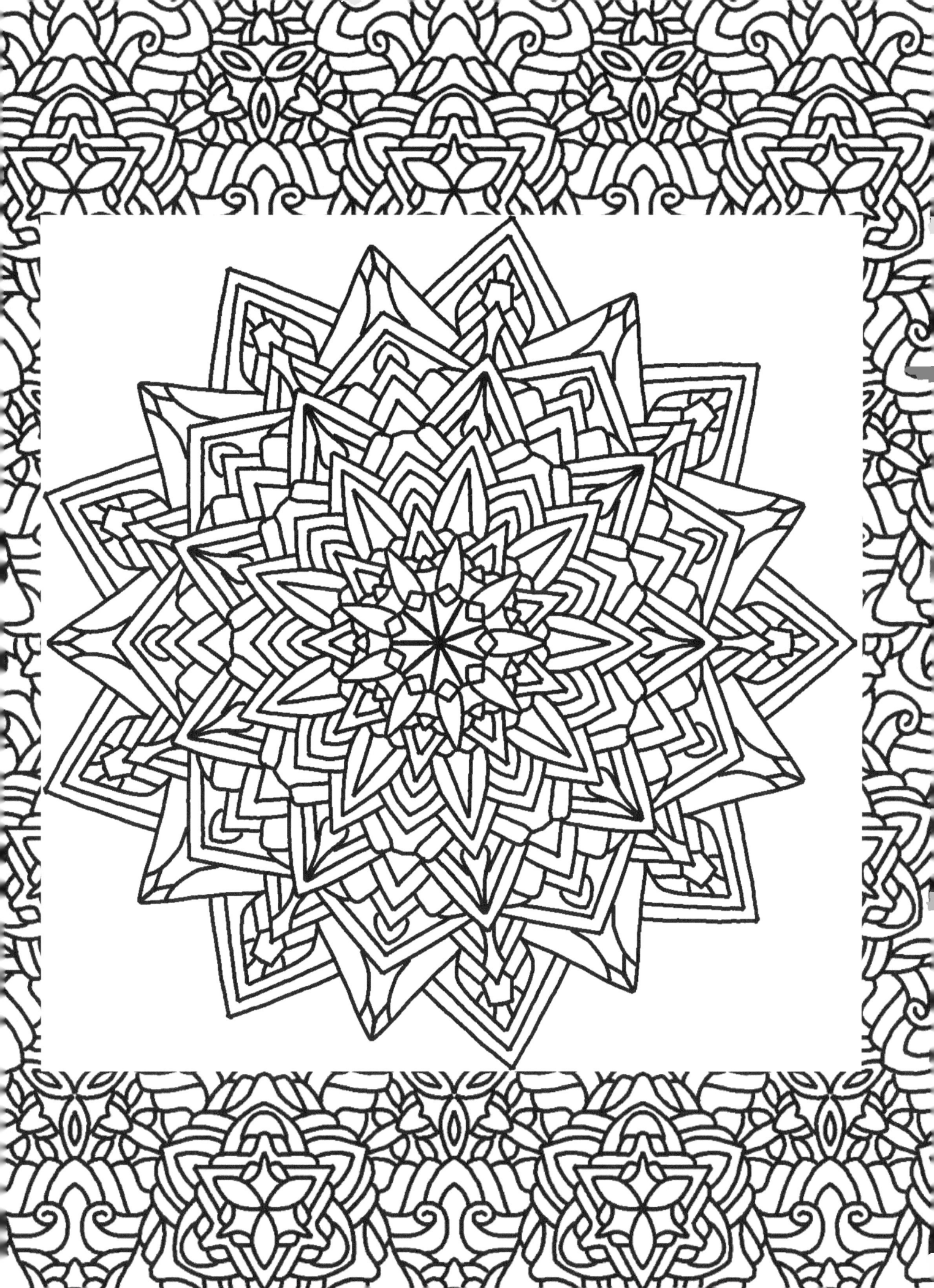

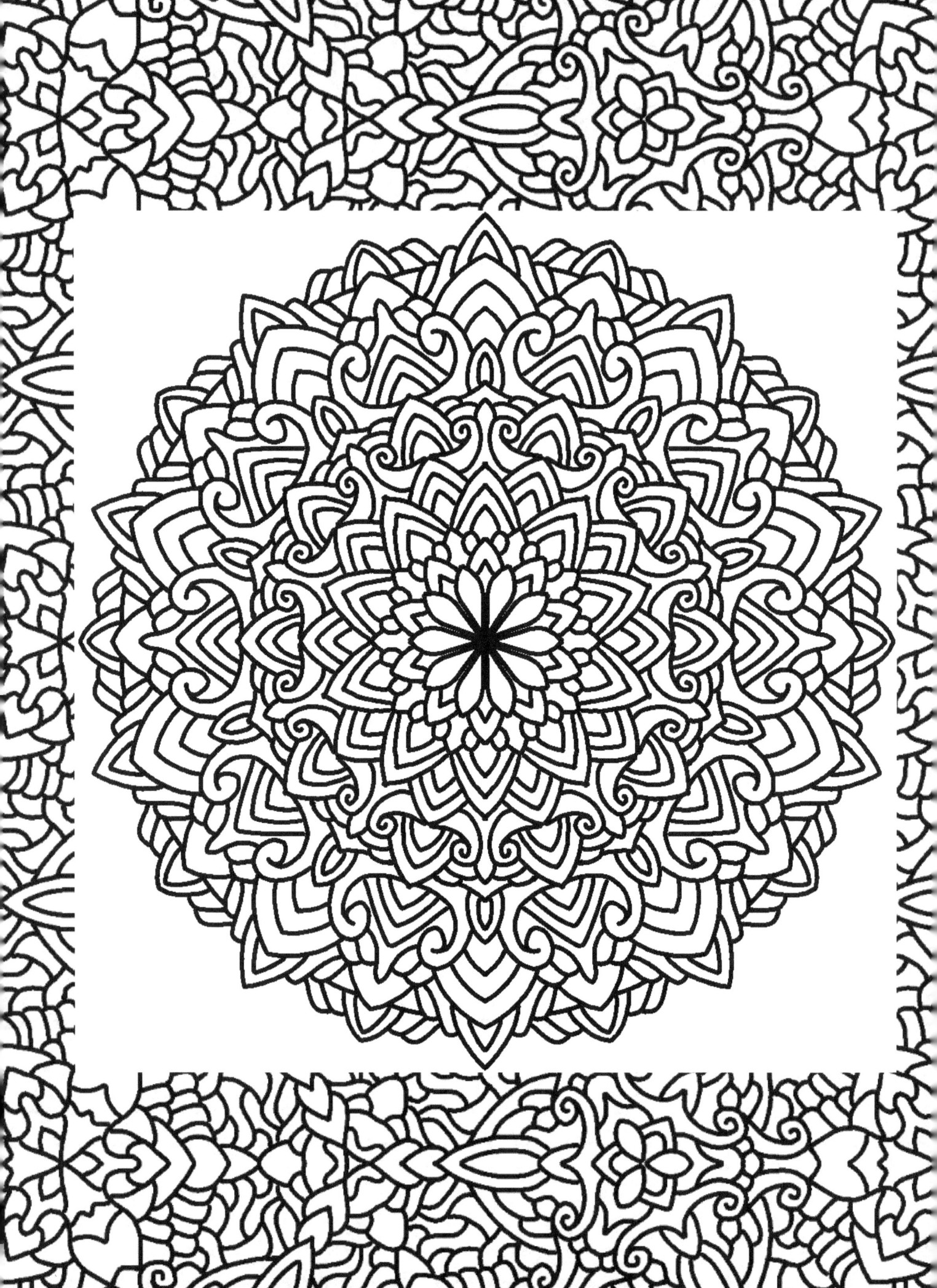

www.ingramcontent.com/pod-product-compliance
Lightning Source LLC
Chambersburg PA
CBHW080606190526
45169CB00007B/2900